TUS CANY INSIDE THE LIGHT

W I N T E R

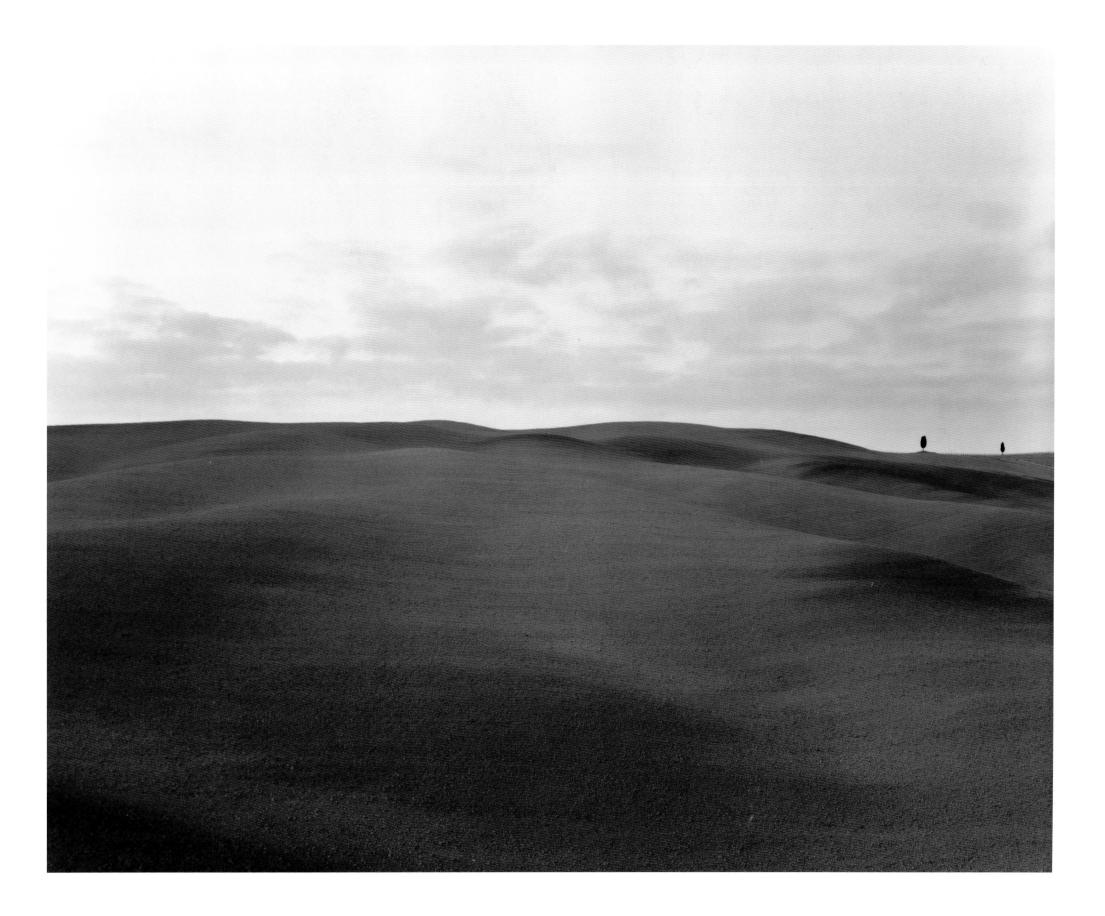

S P R I N G

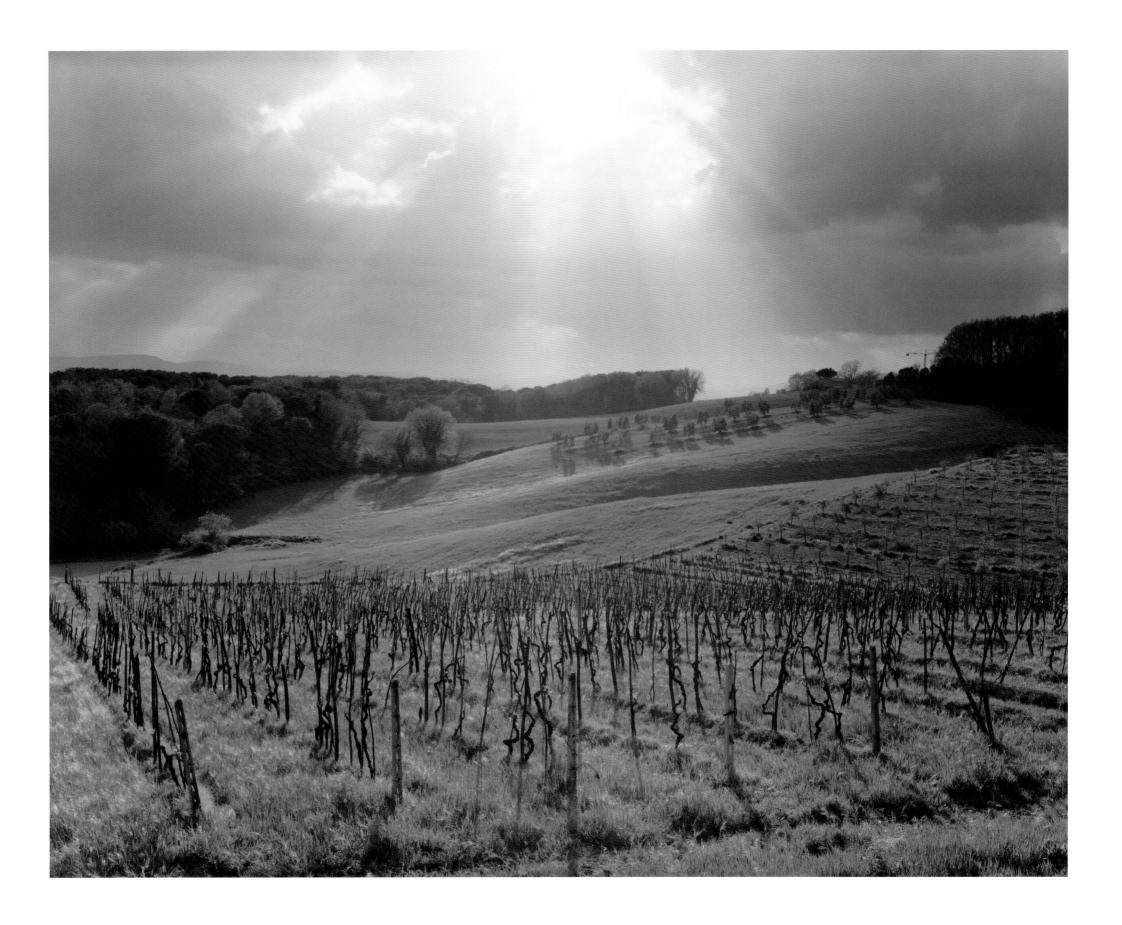

S U M M E R

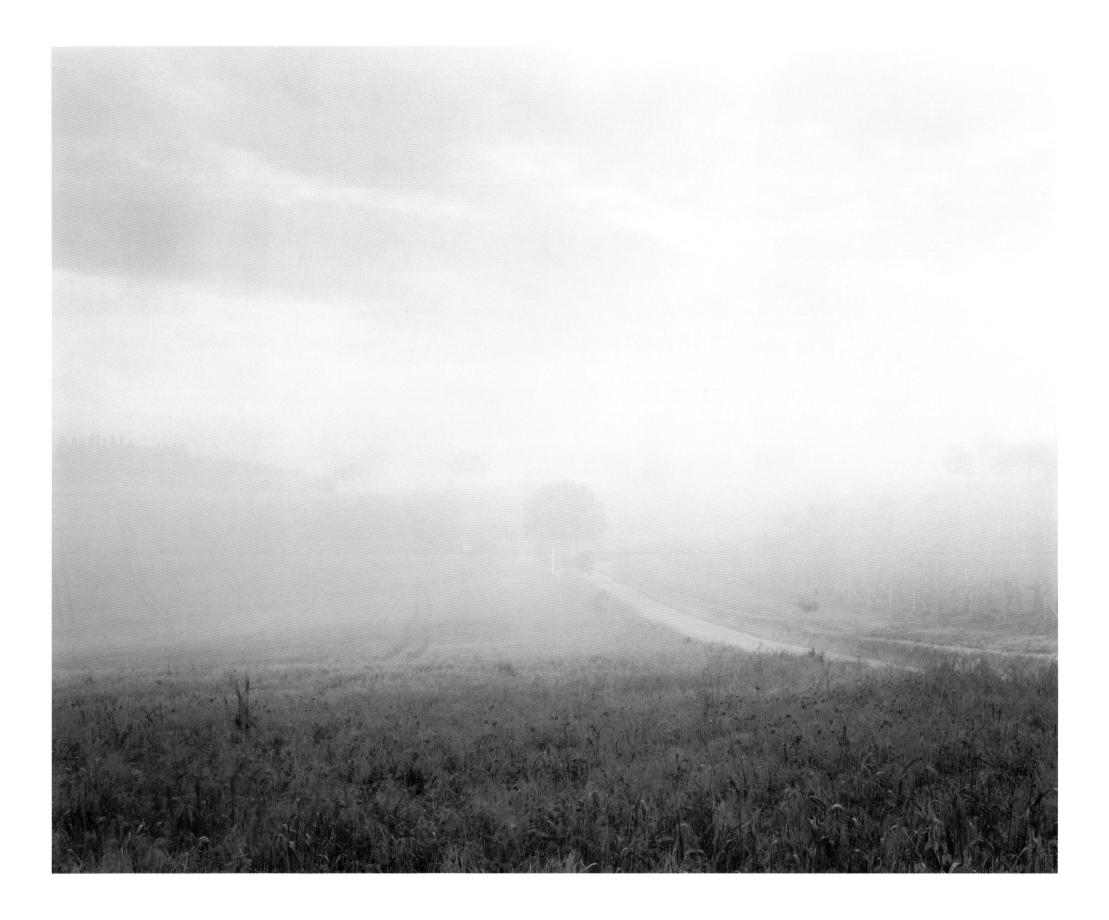

A U T U M N

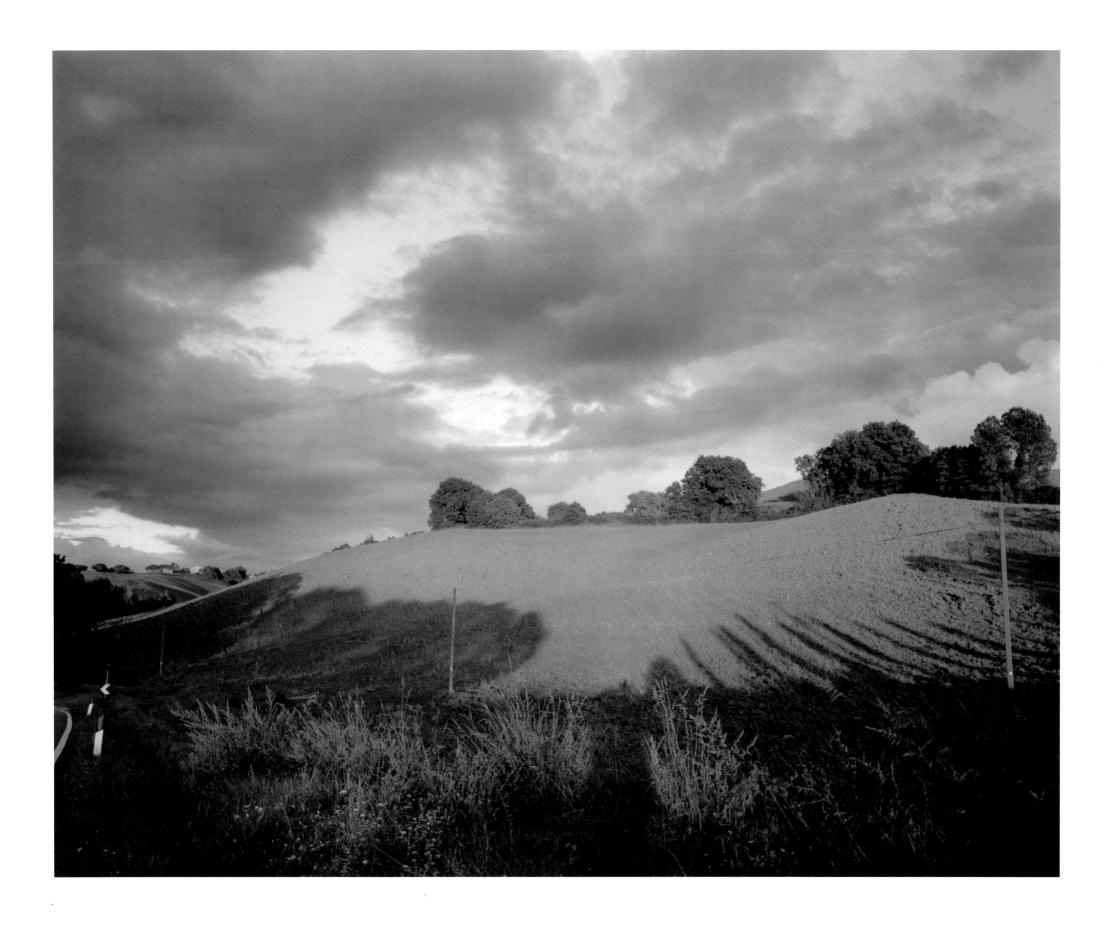

TUS CANY INSIDE THE LIGHT

JOEL MEYEROWITZ MAGGIE BARRETT

Sterling Publishing Co., Inc. New York

light is remarkable. But having come to Tuscany for a decade, we understand that as spectacular as the light can be in other places, it is as a spectator that one usually experiences it. That is, the light is always over there, at a distance, and one stands back and marvels at it. But in Tuscany you are a participant, because the light is all-encompassing. Here, you are inside the light, and therefore connected to all that falls within its sphere: the land, the sky, the people. It is as though each of us has a designated ray of light that stitches us into the fabric of the universe. We experience a profound sense of belonging, not only to each other, but to history, to the moment, and to the possibility of a brighter future. And so we invite you to journey with us through the seasons, in the hope that each of you will find your place inside the light.

WINTER

o this is it ...the pure winter light, pulsing outside the dense fog as though all the stars that ever were and ever will be have joined forces, pixilating the air with a mist of pulverized diamonds.

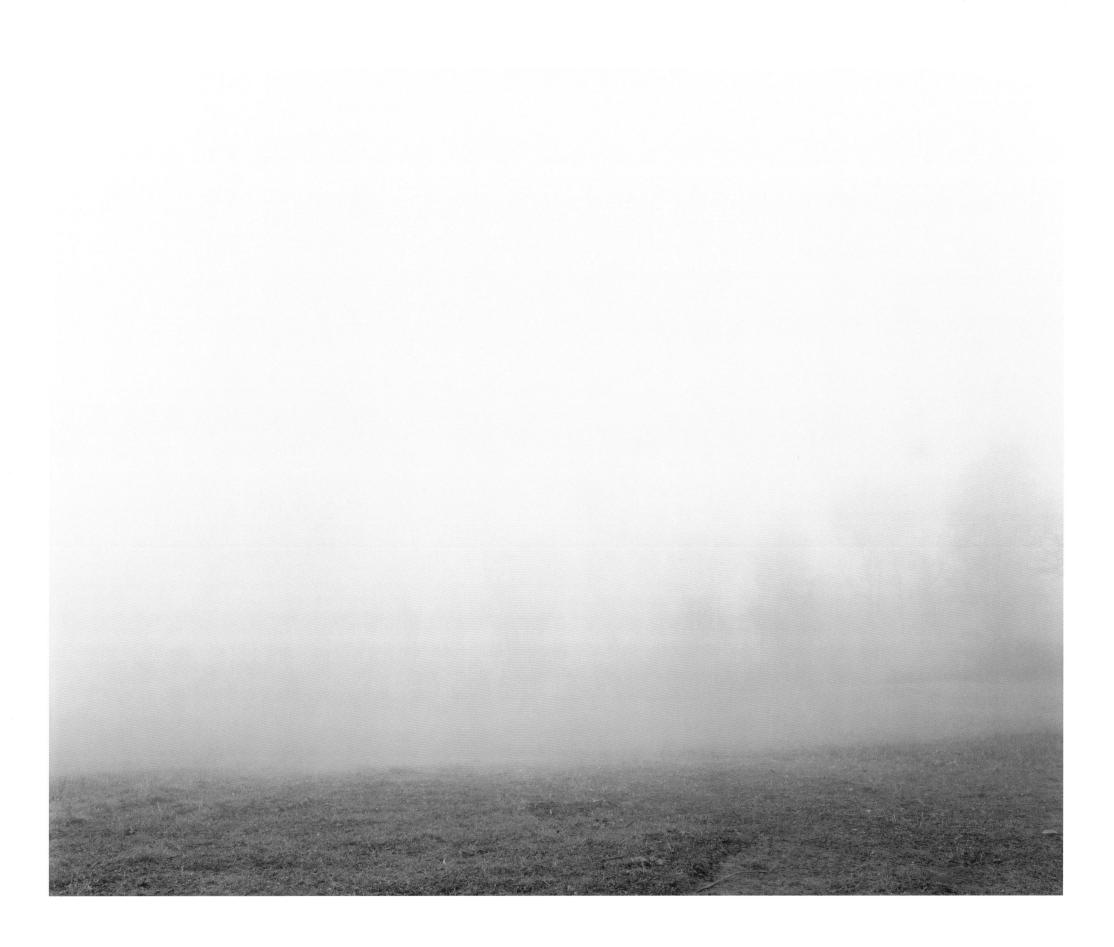

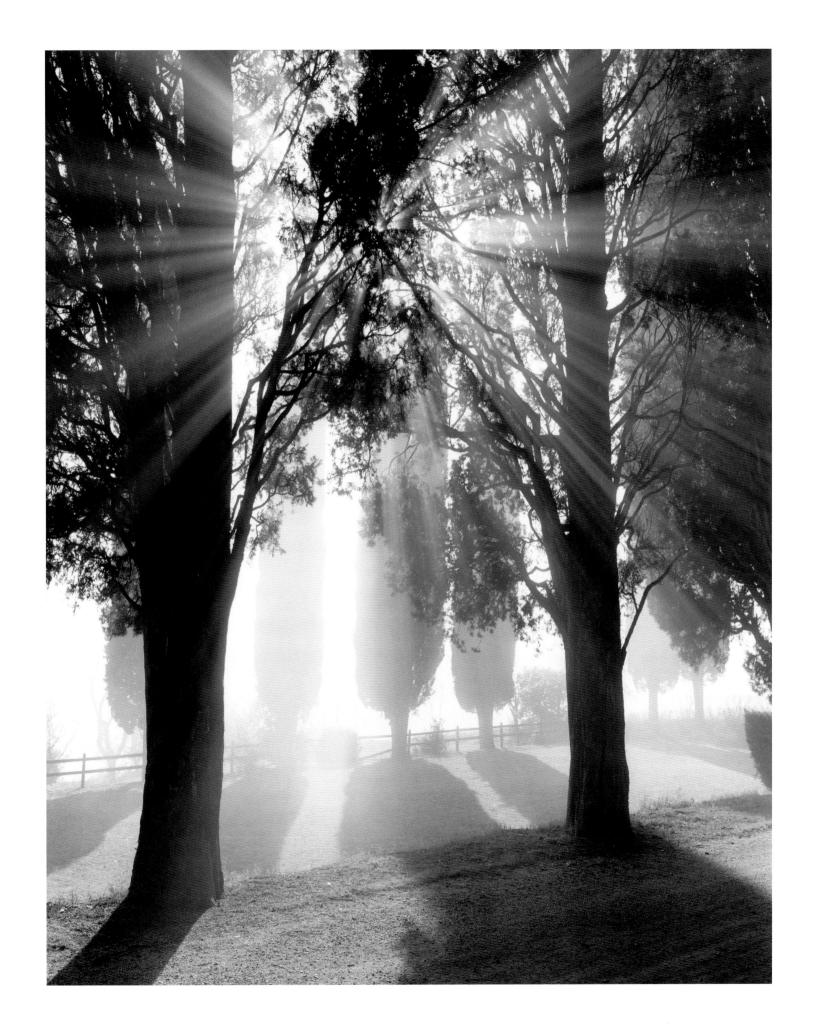

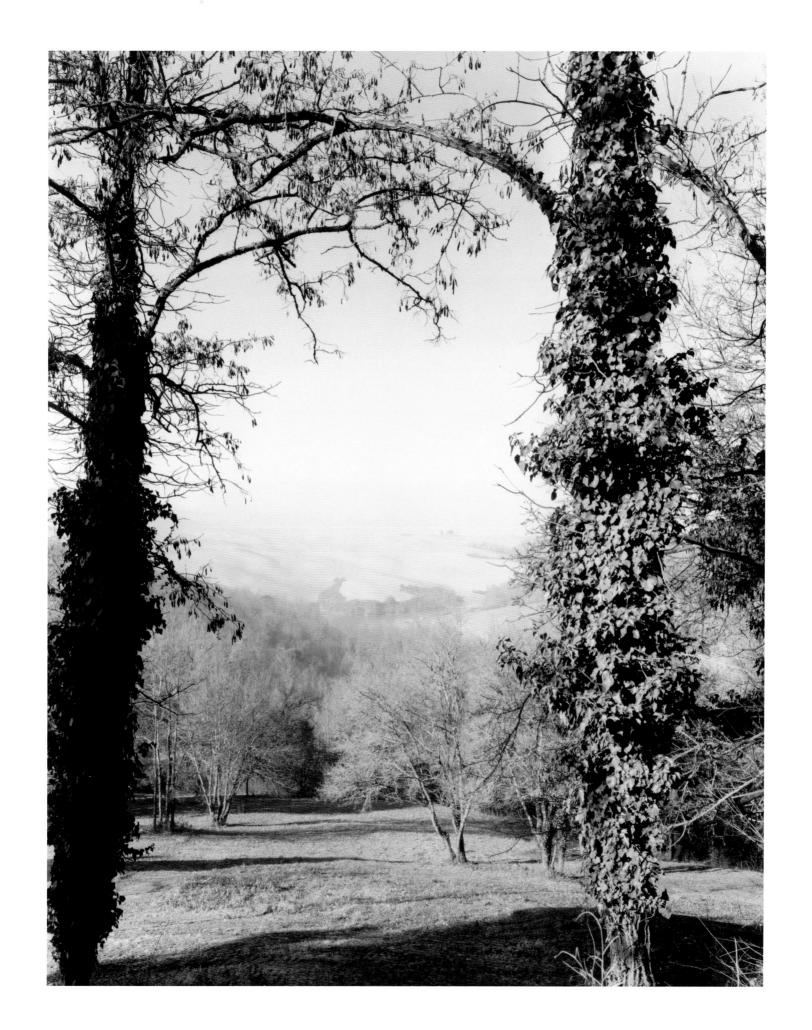

lazing in the sunlight. Barren of any seed or outcrop, the hills become pure form, color, and texture. And, oh, what color! At first glance a sandy gold that seems to graze the retina, and once grazed looks anew and sees sage and mustard and ochre and, up there in a fold near the sky, a lick of lavender. The earth's crumbly texture, made from plowed earth, rain, and perhaps a sprinkling of olio, resembles a coarse, hearty polenta. And so this undulating terrain of texture and color pits itself against the opaque blue of the sky, and you long to take a bite. What makes this so immensely satisfying, this marriage of opposites, the one so rough, the other smooth? Sky and earth, each remarkable on its own, when layered one atop the other create a profound union, the likes of which we mortals dream.

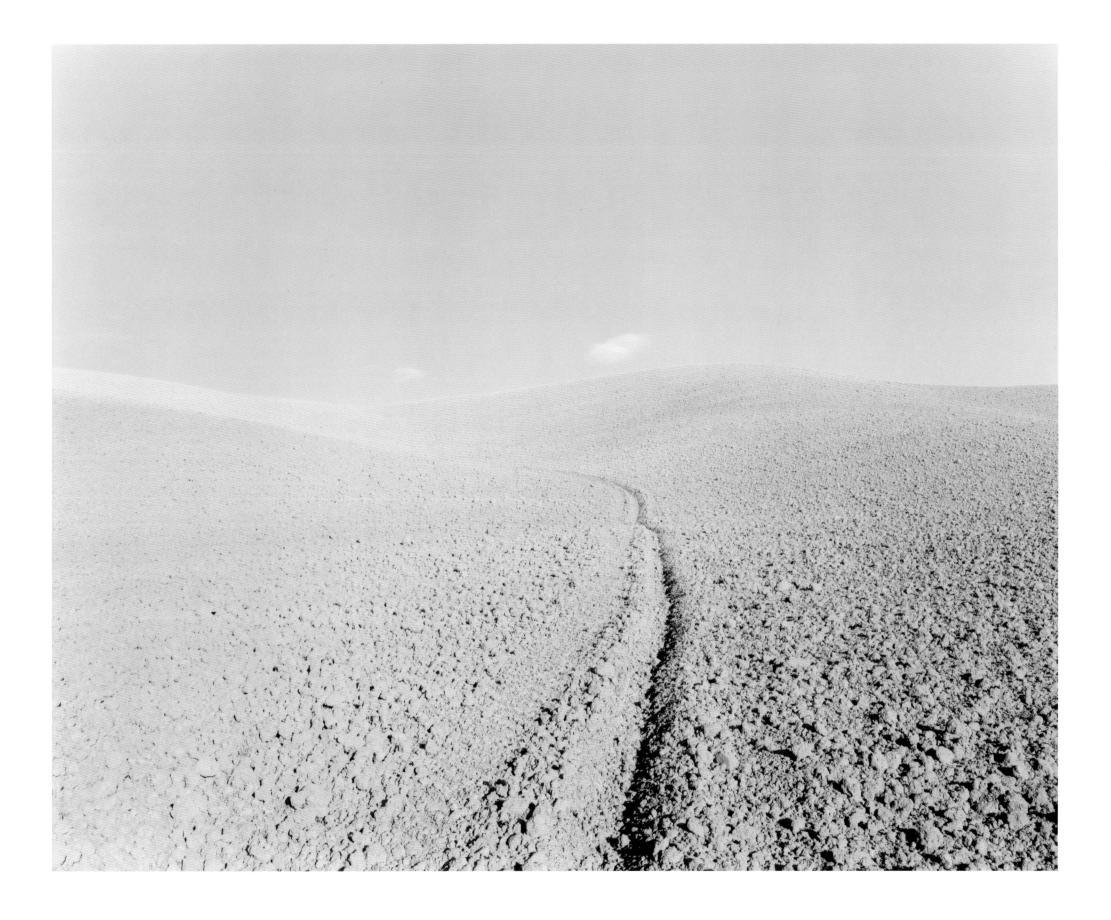

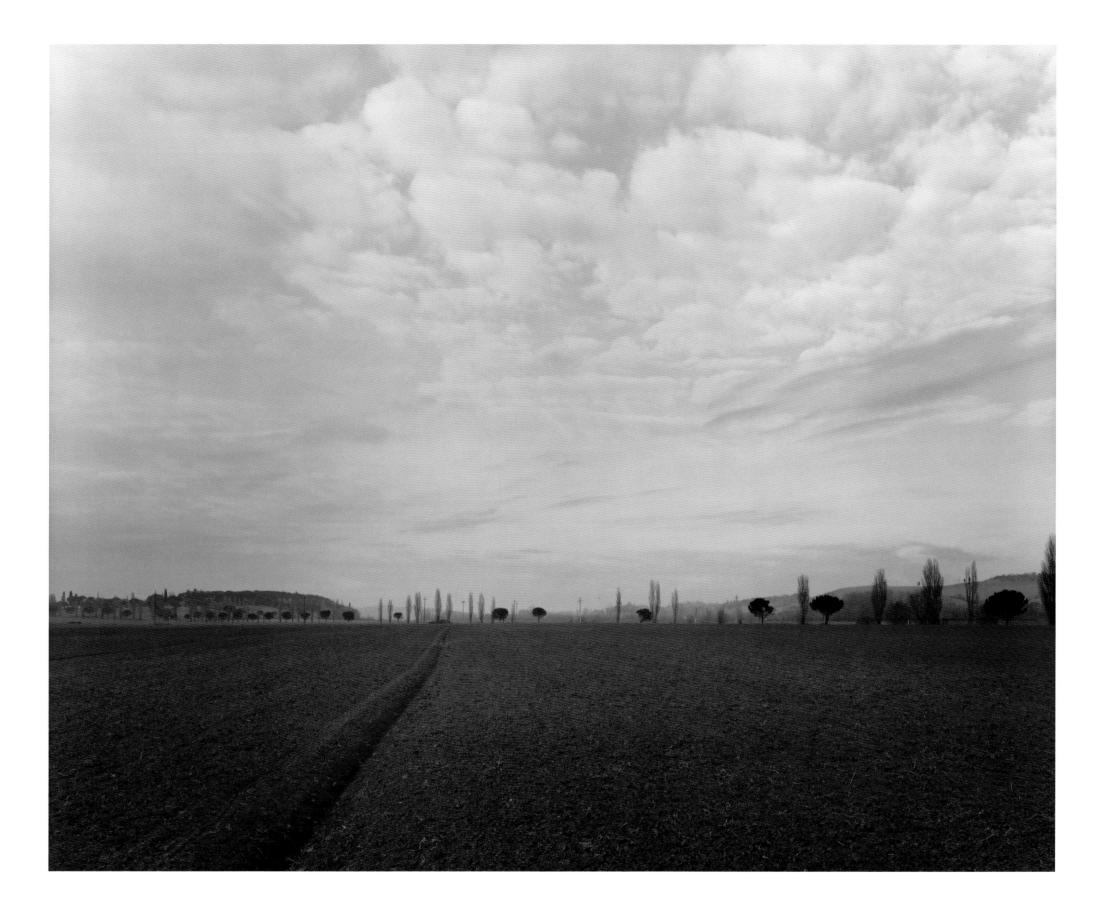

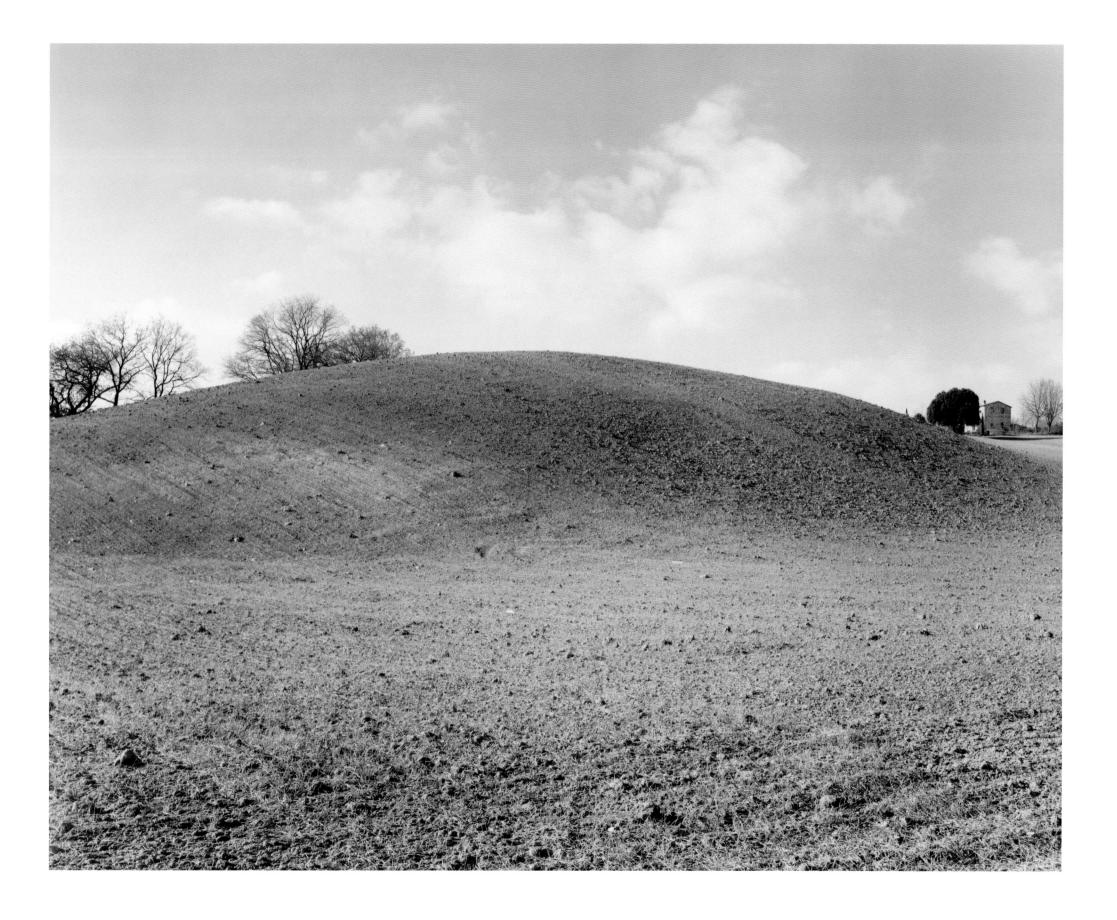

A tufted line of trees crosses the horizon: above,

the milky blue sky; below, rolling down the slope, a field of threadbare carpet. Centuries of sowing and growing and harvesting have worn the earth down like a well-trod stair runner, reminding us that that which has been eroded by time has also become its essential self.

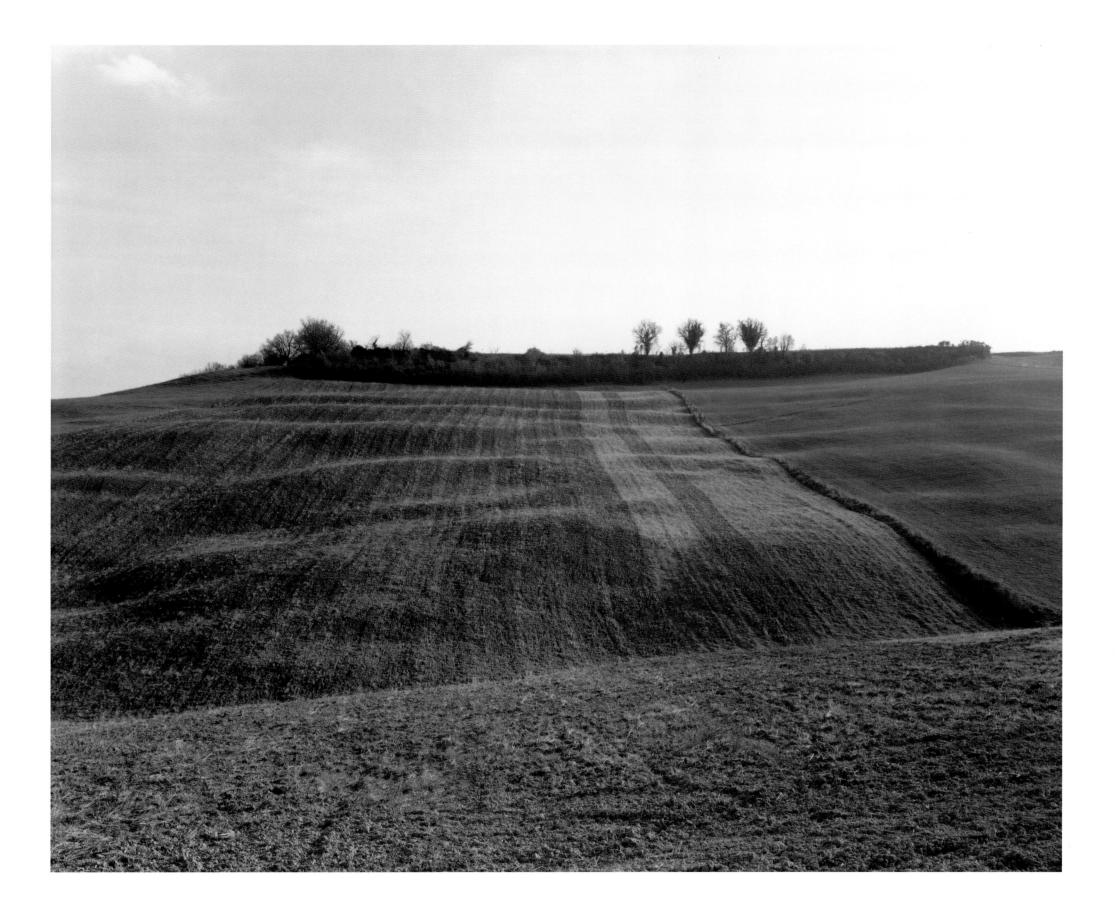

Today the frost is so dense it looks like a light

fall of snow. Down in the valley a gleaner, bent in the morning sun, picks and peels the last of the dried corn. A tractor scrapes its blades through the frozen earth, a sound that puts us in mind of summer. Clumps of frozen, muddy sod—turned over back in the autumn—sit now like truffles dusted with confectioner's sugar, while between the clumps the winter grass tinkles with icy light. We wait in the car in our down jackets and, in spite of everything that tells us it is winter, feel the sun as warm and gentle as a June morning. Time and light are inextricably linked here, so that each season holds within it the other three, as though the light gathers time and gives it back to us in its totality.

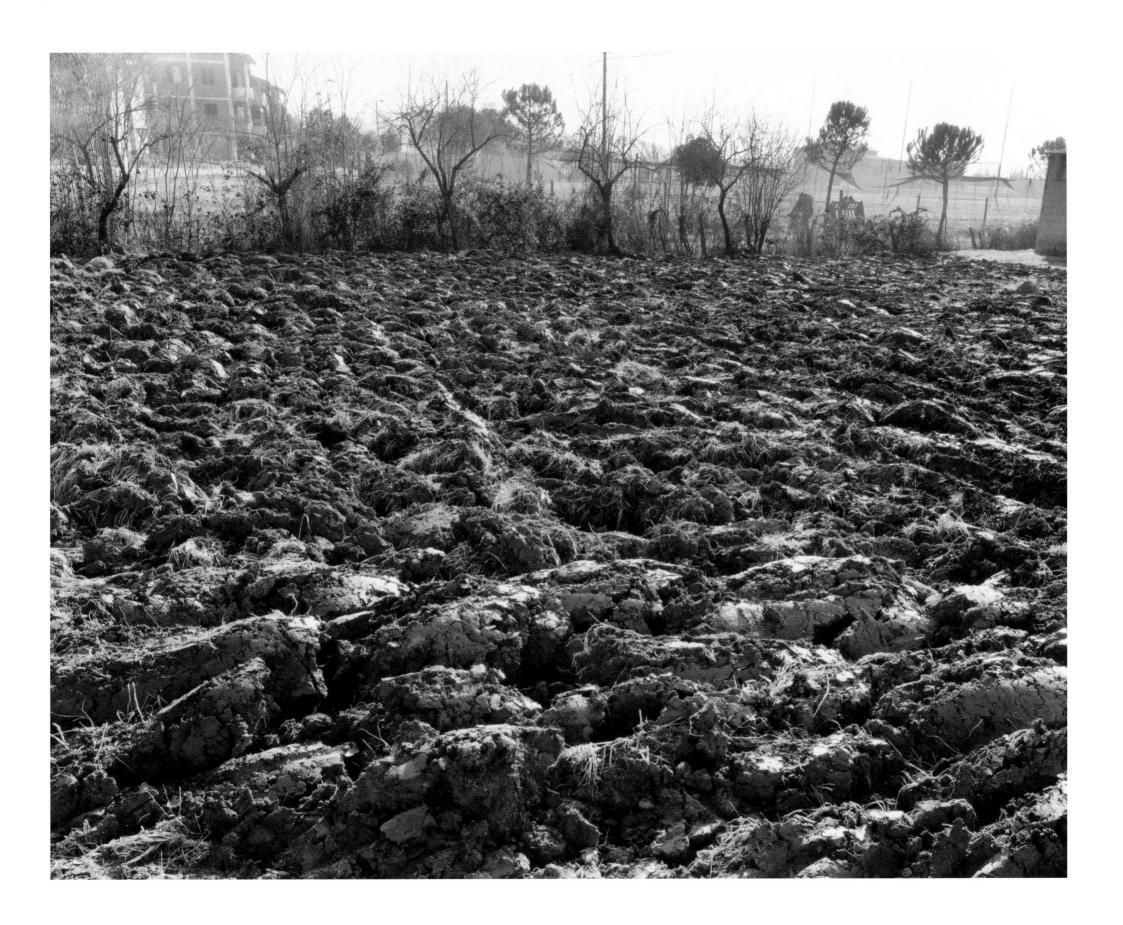

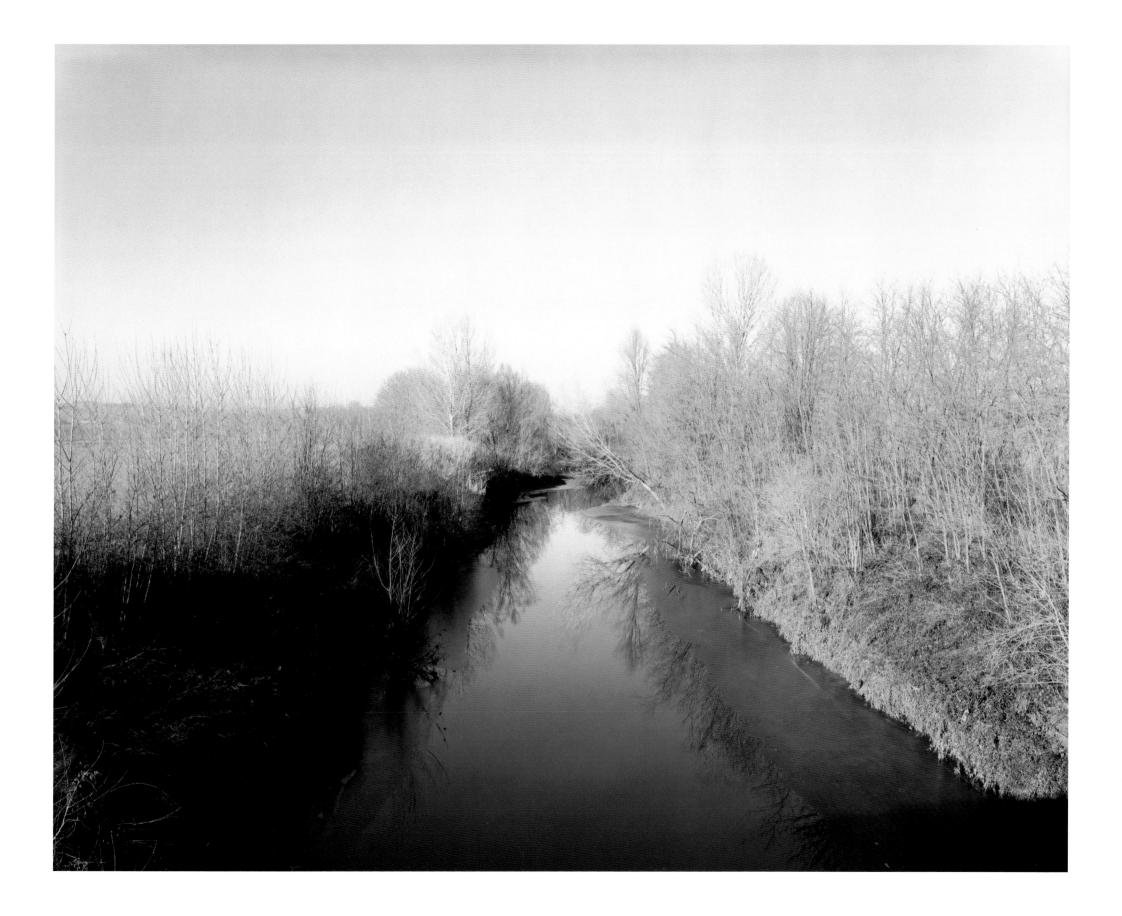

PLATE 10

Overleaf: Plates II and 12

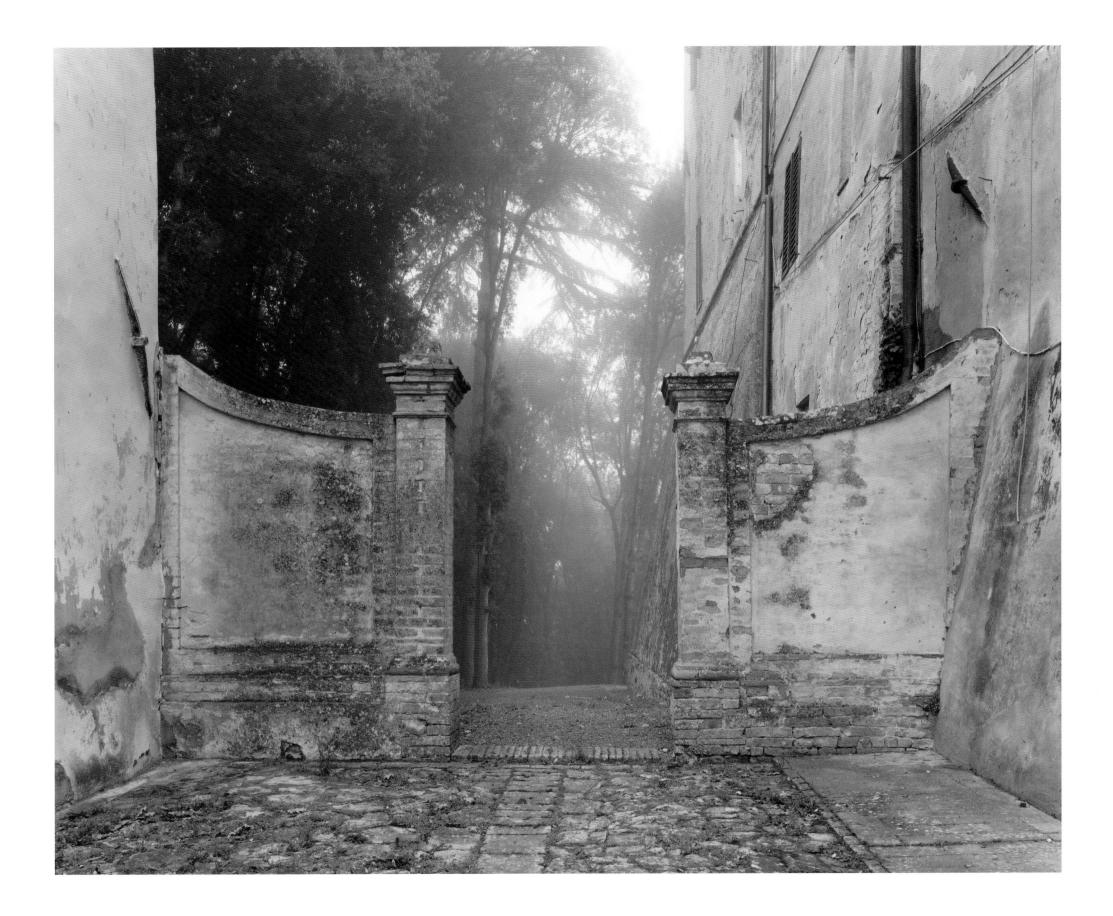

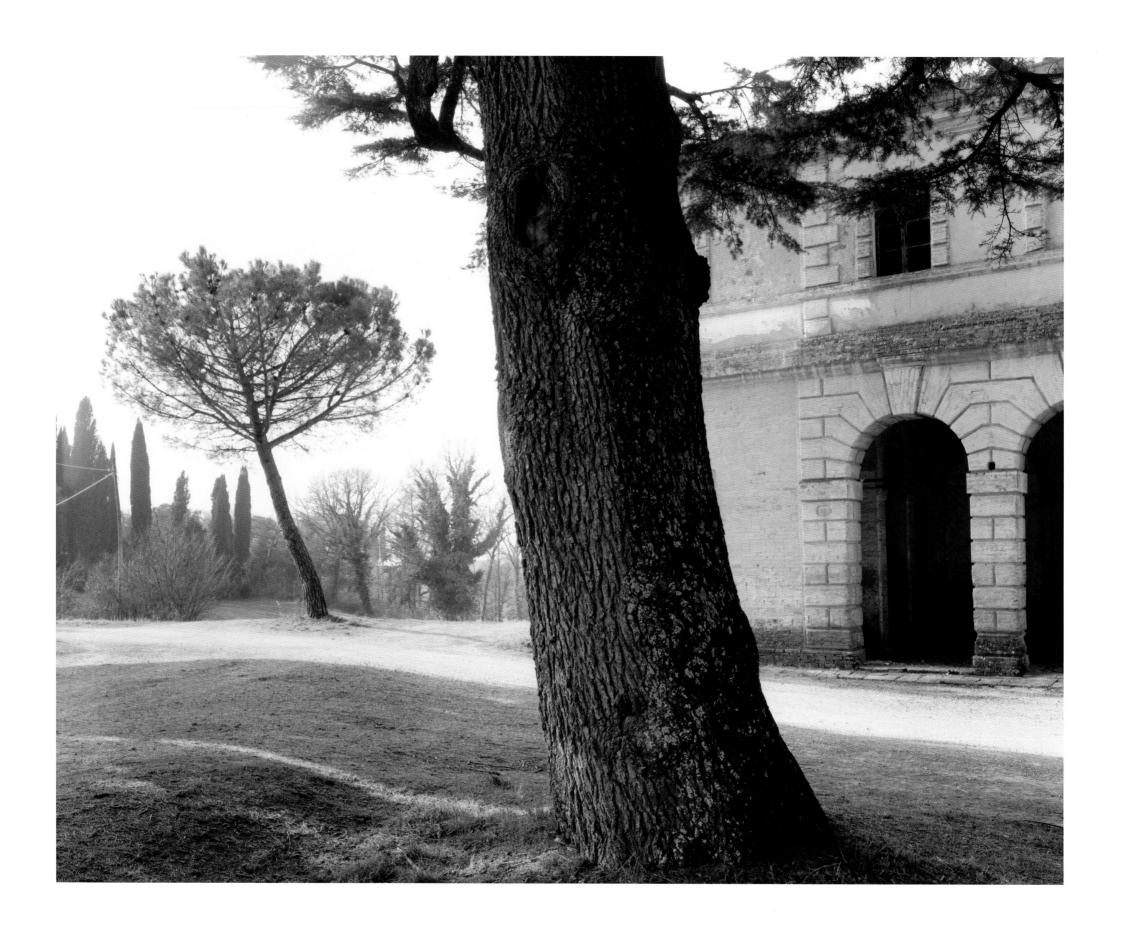

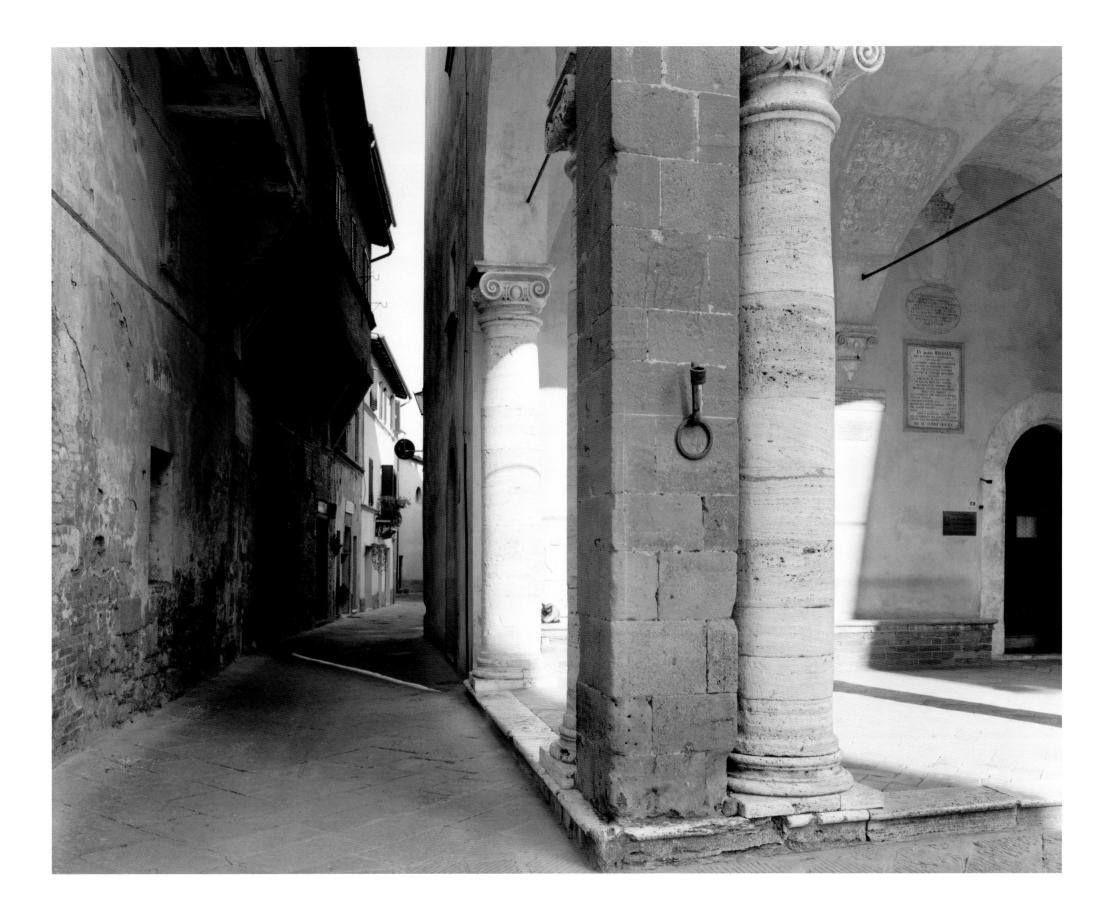

I am mesmerized by a wall of succulent ivy, and wonder why this seemingly mundane piece of nature captures my attention. The longer I look, the more I see it as a recipe for successful living. Just a few weeks ago there was not a leaf to be seen on this wall. Back then, it appeared a skein of dead vines, barren, tattered, clinging to the stone from centuries of habit. But of course, it was not dead, merely dormant. This is the simple lesson that nature reveals to me this morning: the rebirth we so desperately long for cannot be gained solely by searching and inventing and consuming. To grow, we must also be prepared to lie dormant.

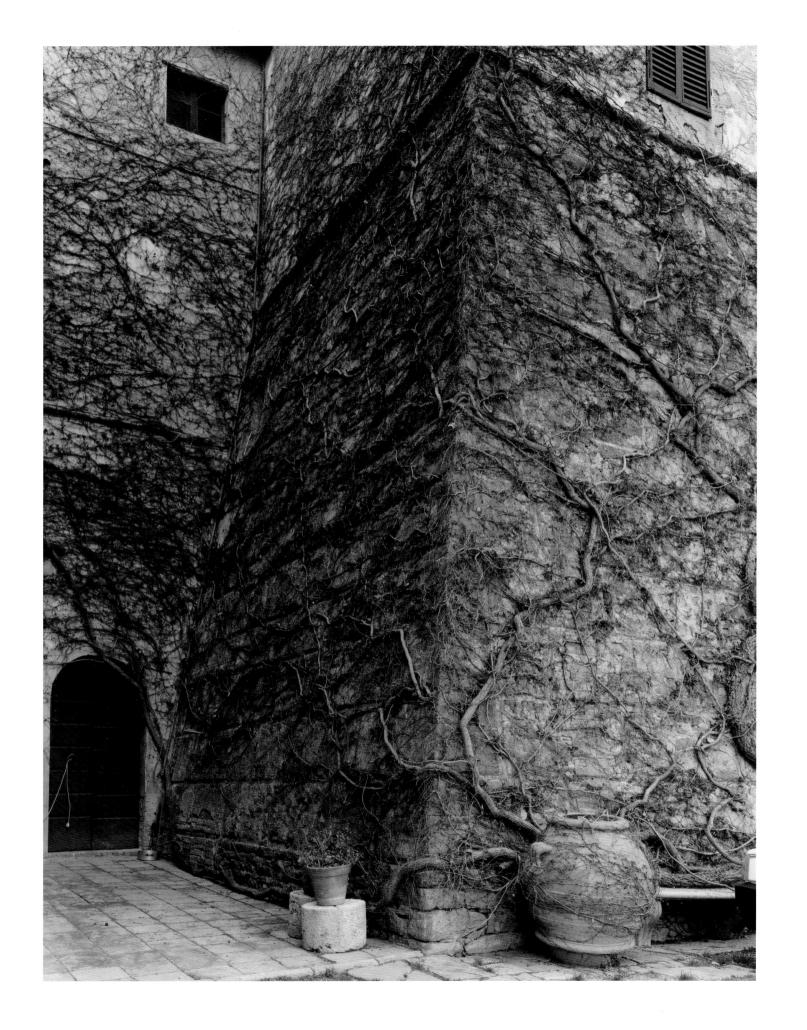

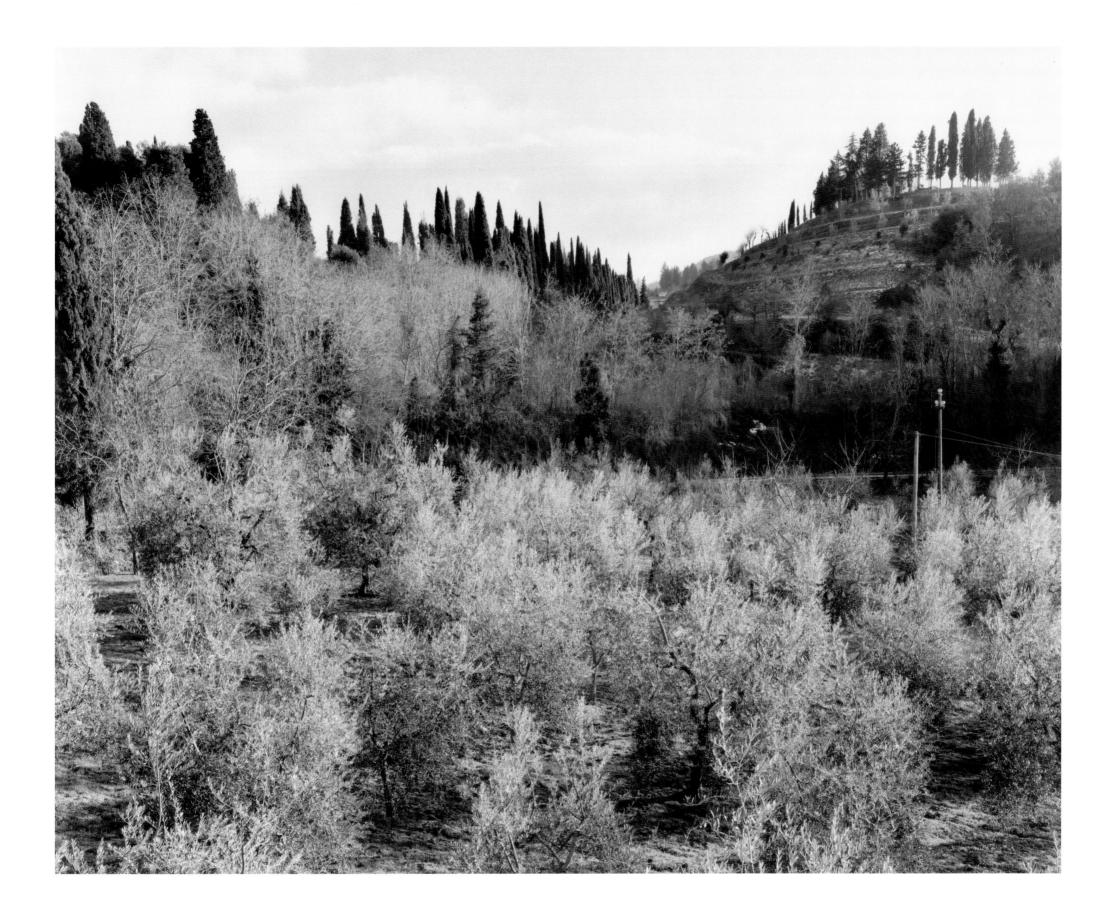

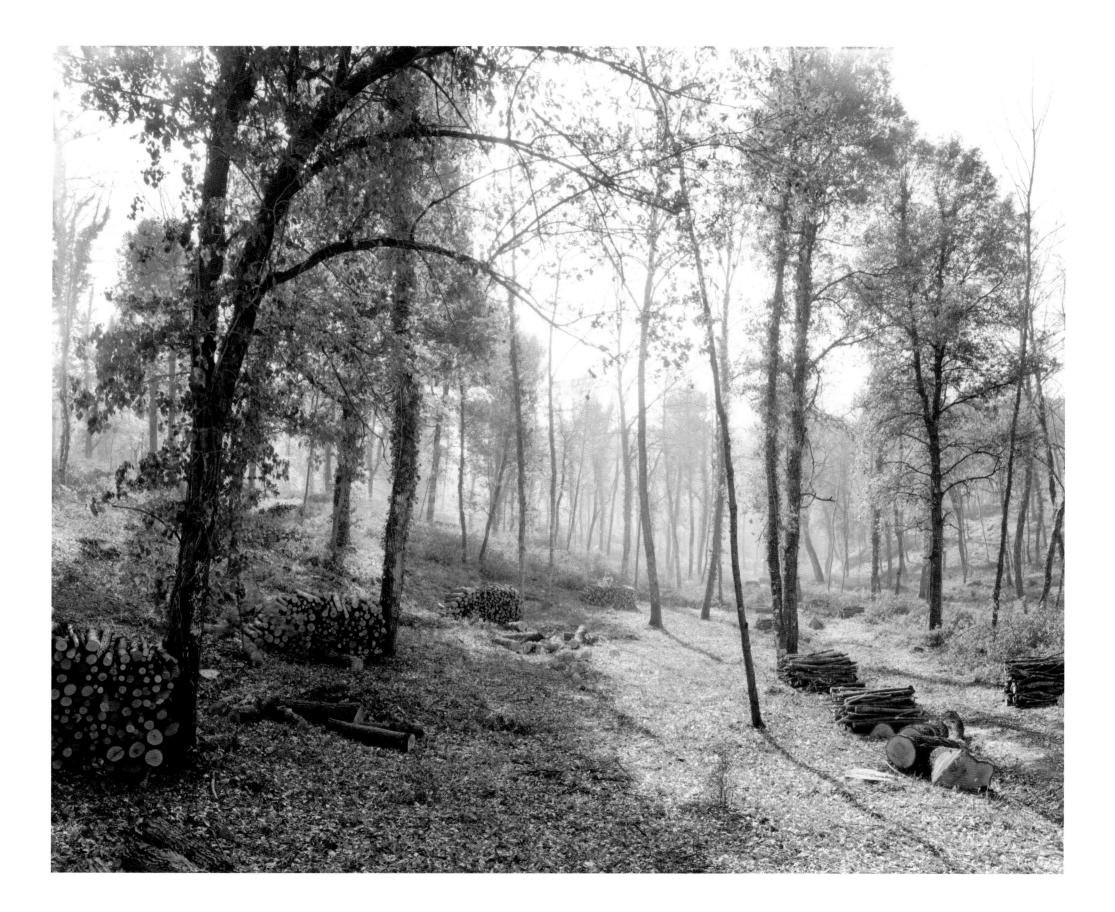

Inside the old guardhouse the light filters in

from one small window and scatters through the dust motes before coming to rest on a spread of ruby meat glistening on the table. The tap, tap, tap of exquisitely sharp knives accompanies the spare movements of three men butchering wild boar. The flesh appears lit from within, as though the creatures' spirits still inhabited their separate piles of suet and ribs, loin and liver, trotters and chops. There is nothing tragic here. Sides of meat hang like violins seasoning in the still, cold air. There is something almost holy about this ritual. Maybe it is the knowledge that the pigs led a good life here in the woods, well fed, chomping and romping in the mud for four seasons, and now their time has come.

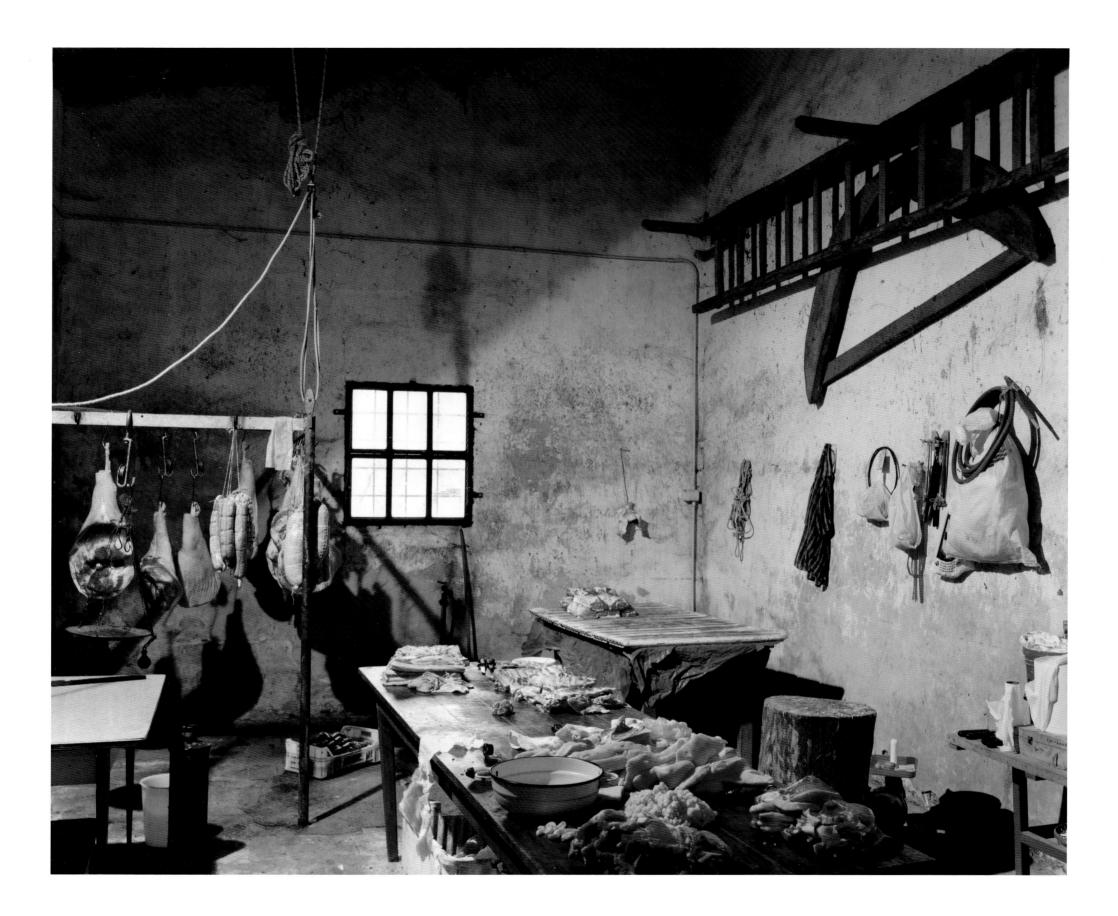

PLATE 17

OVERLEAF: PLATES 18 AND 19

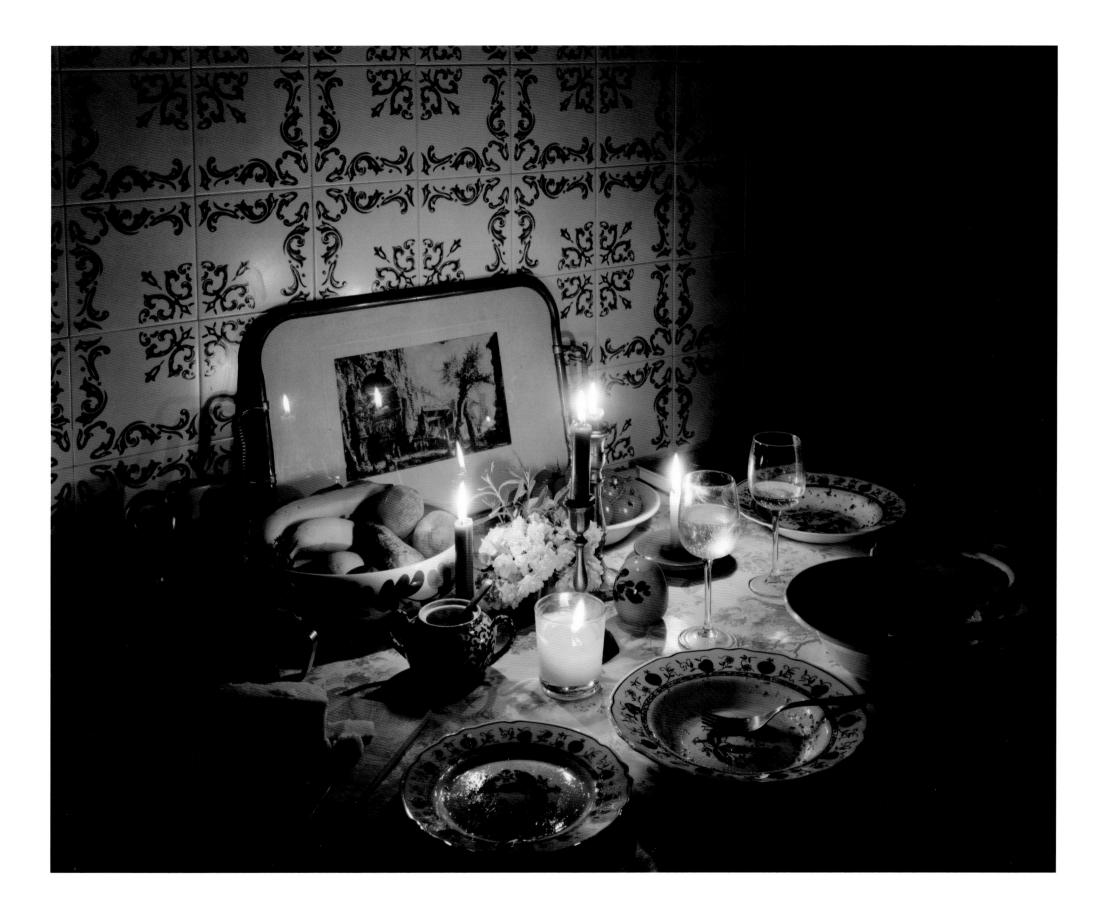

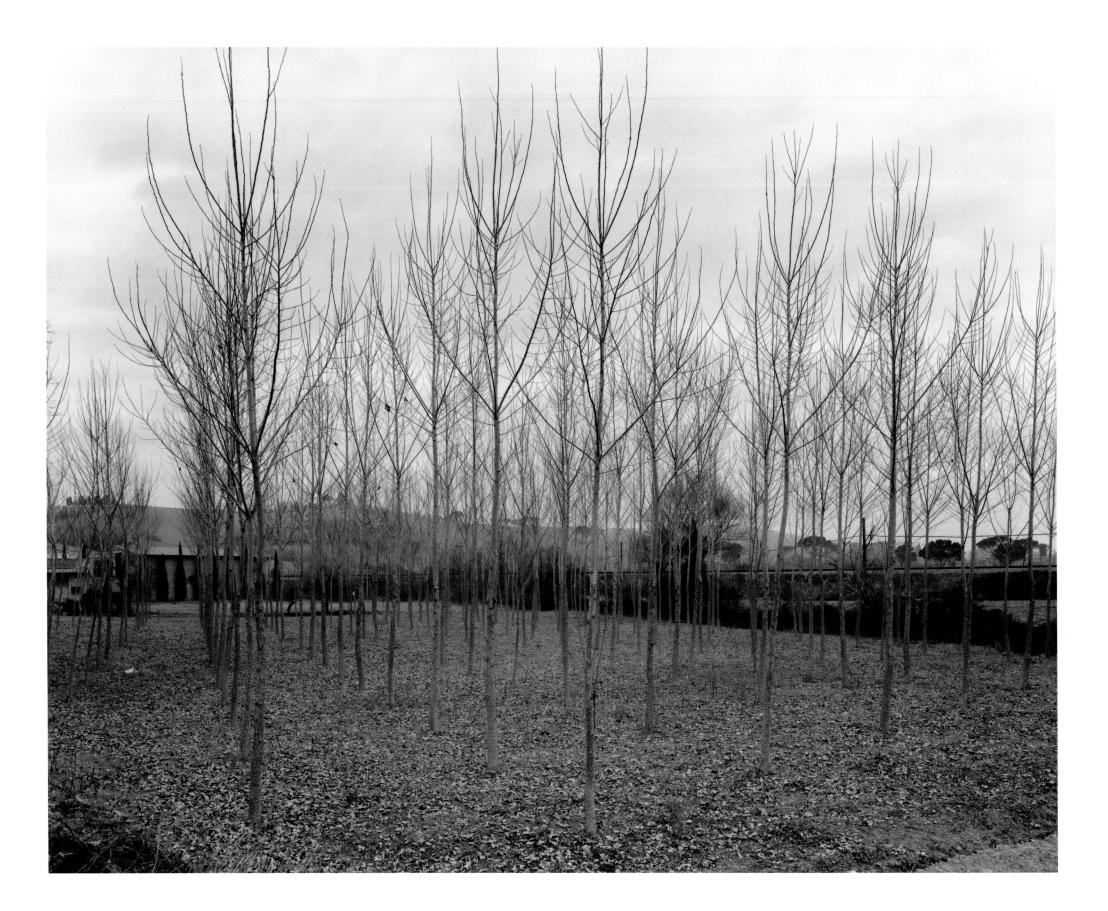

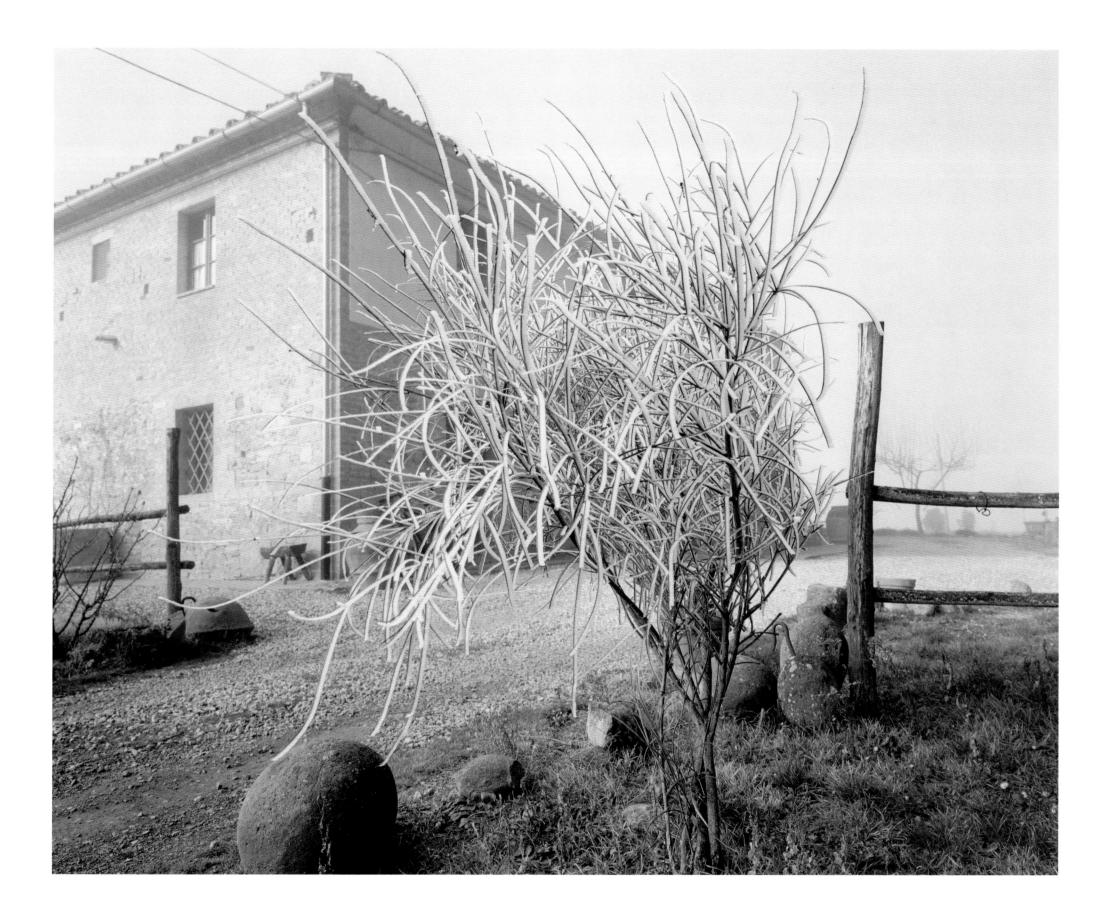

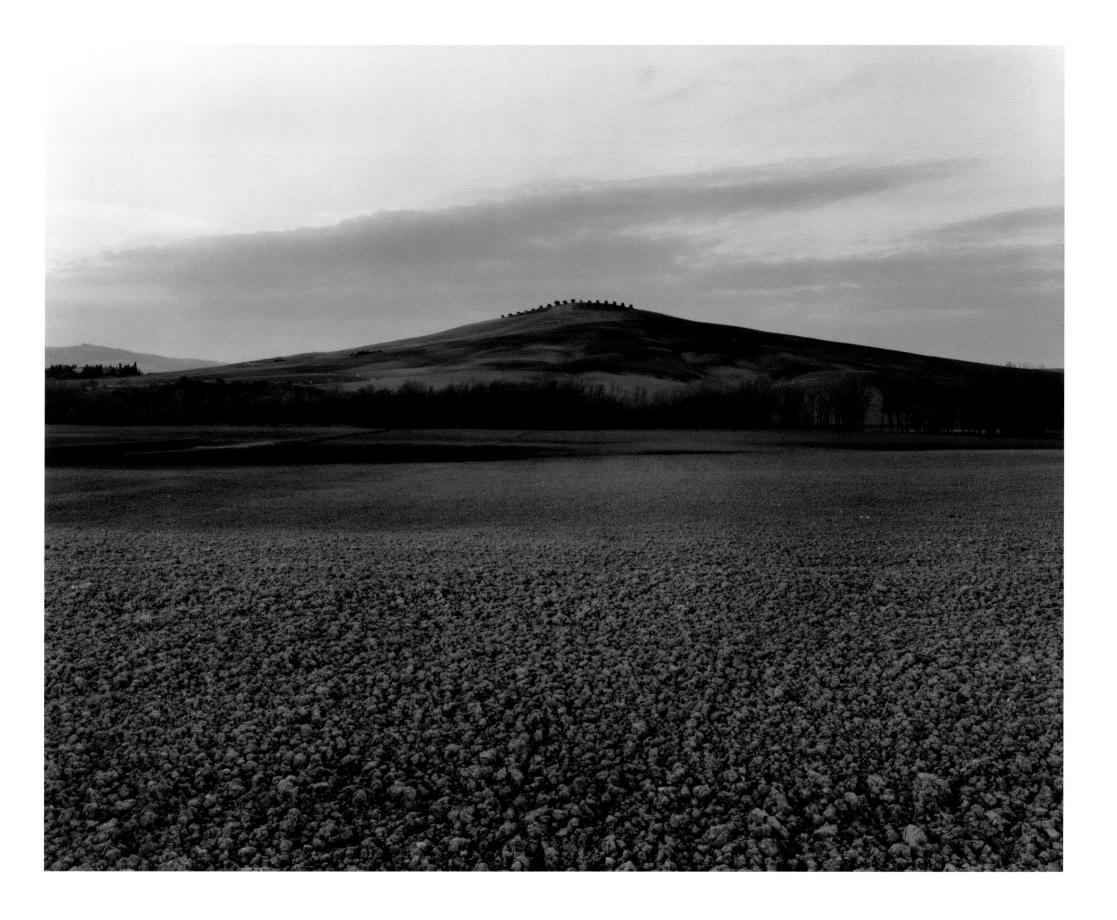

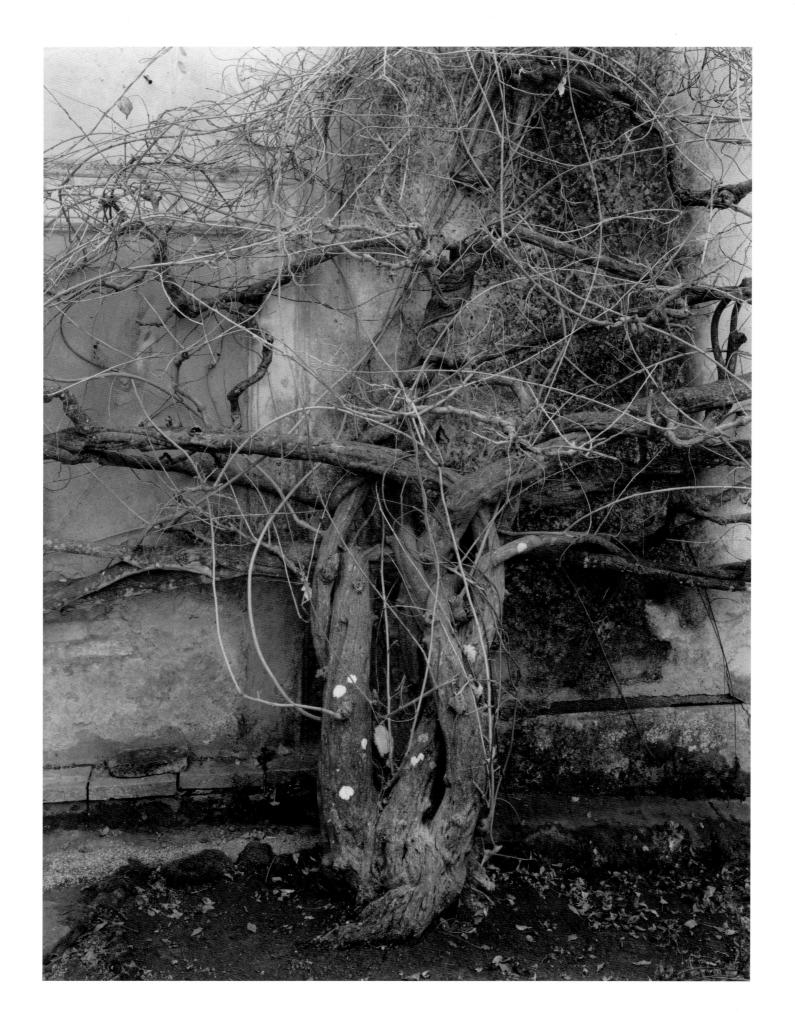

S P R I N G

The wisteria is raining from its sooty vines, a drape of mauve lament. Pendulous, faded even as it arrives, yet still a gasp against the pale, sandy stucco. As wistful as its name, this exquisite blossom that comes at the beginning of spring appears old before its time, emblematic of life in its grapelike formation, yet funereal in shade and scent. Wisteria. The Queen of Ambiguity.

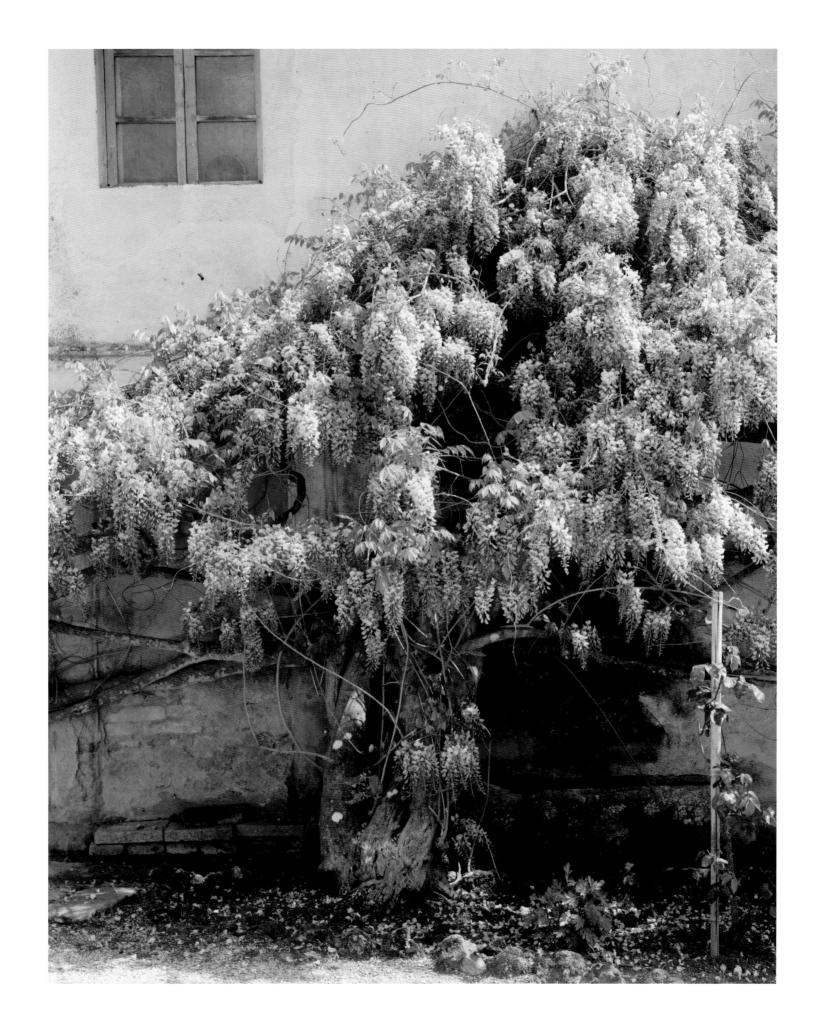

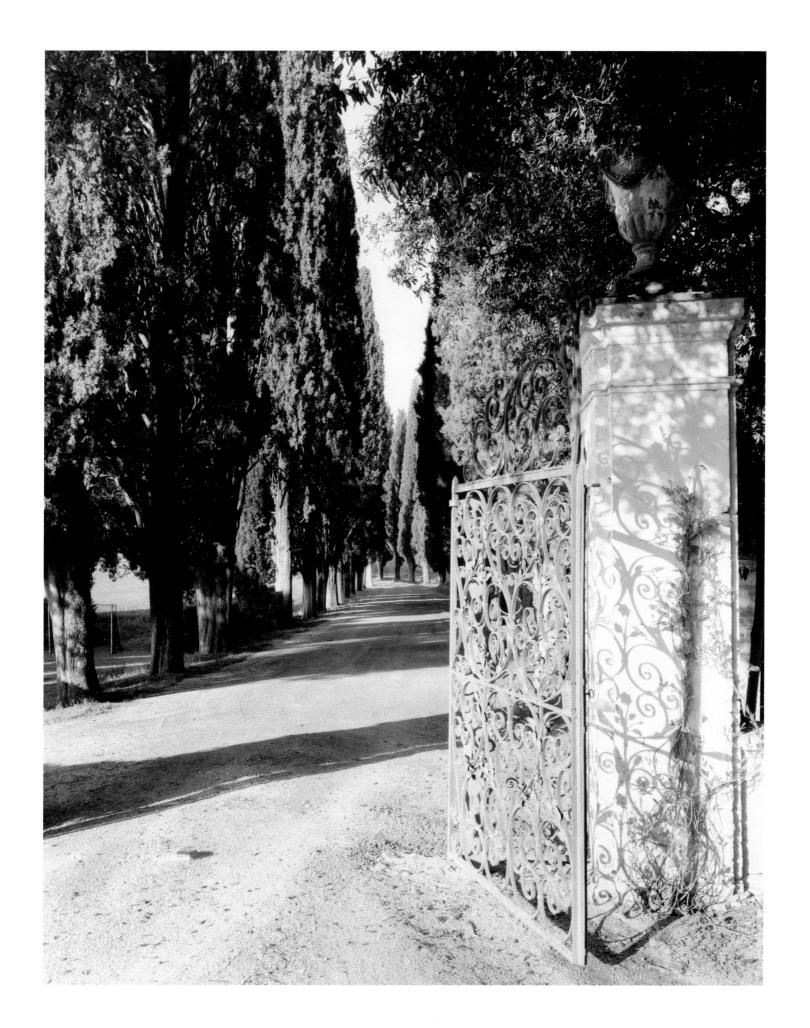

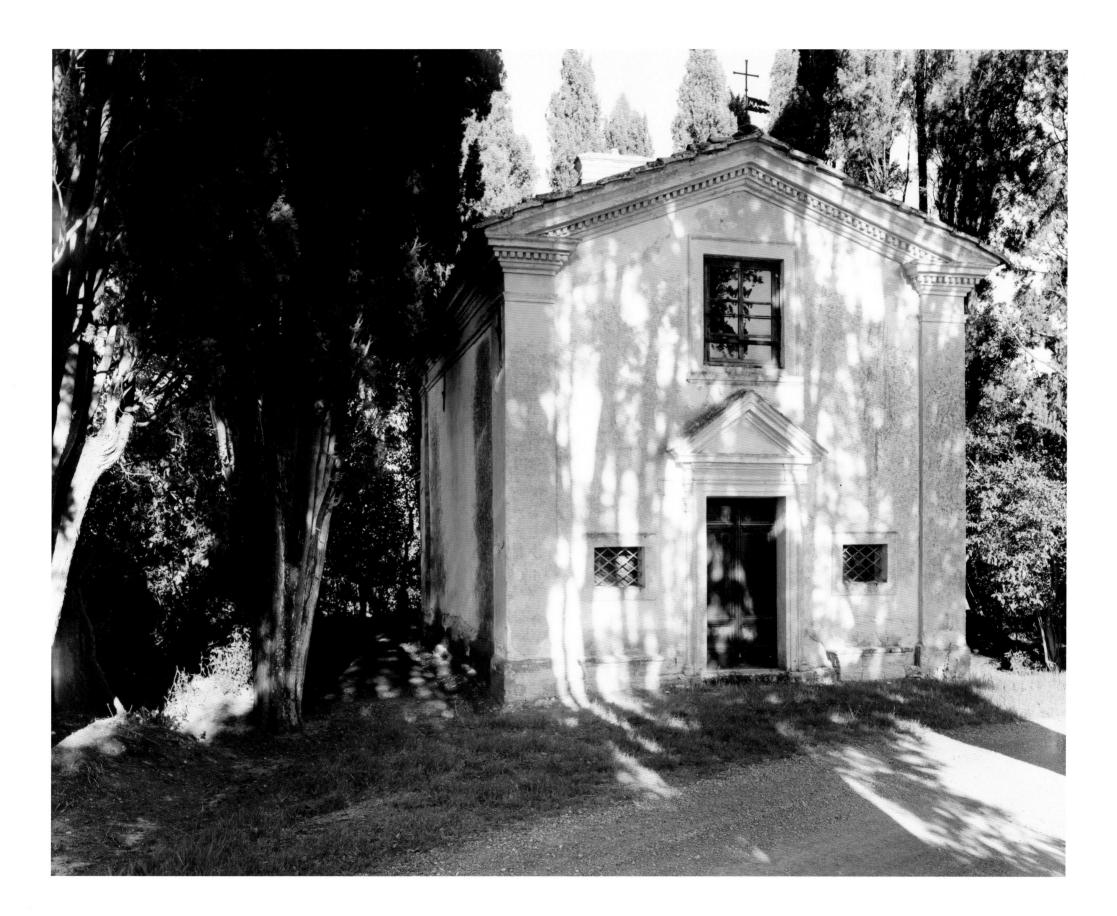

My husband says it's the day the air turned green, and so it is. A vibrant buzz of chartreuse sings out from every branch, while the green of the young wheat fields has the same urgent tone as blood, the same thrill, danger even, as if to say every birth carries its imminent death.

We look down and across a small valley formed by a slope of tilled earth on the left and an equally sloping vineyard on the right. The one is mouth-wateringly empty, the other a dance of charcoal stumps whose outstretched arms reach for each other as they jig across a fuzz of grass. It is mad here. Wild wood doves coo nonstop in a nearby copse, and even though the air is still, even though the landscape appears not to move, the impression of latent energy is enough to make one strip off one's clothes, leap across the berry canes, and cavort with bacchanalian abandon, down there, down in the beginning of time.

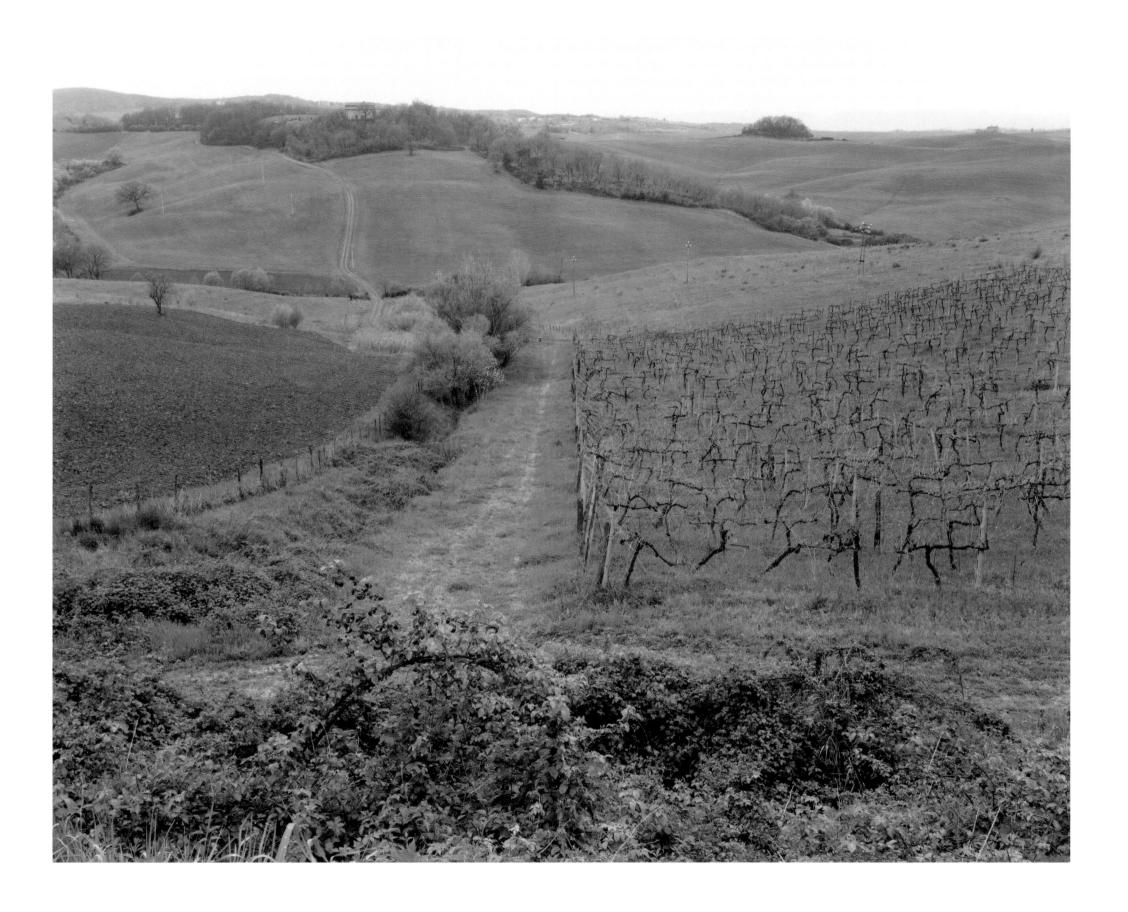

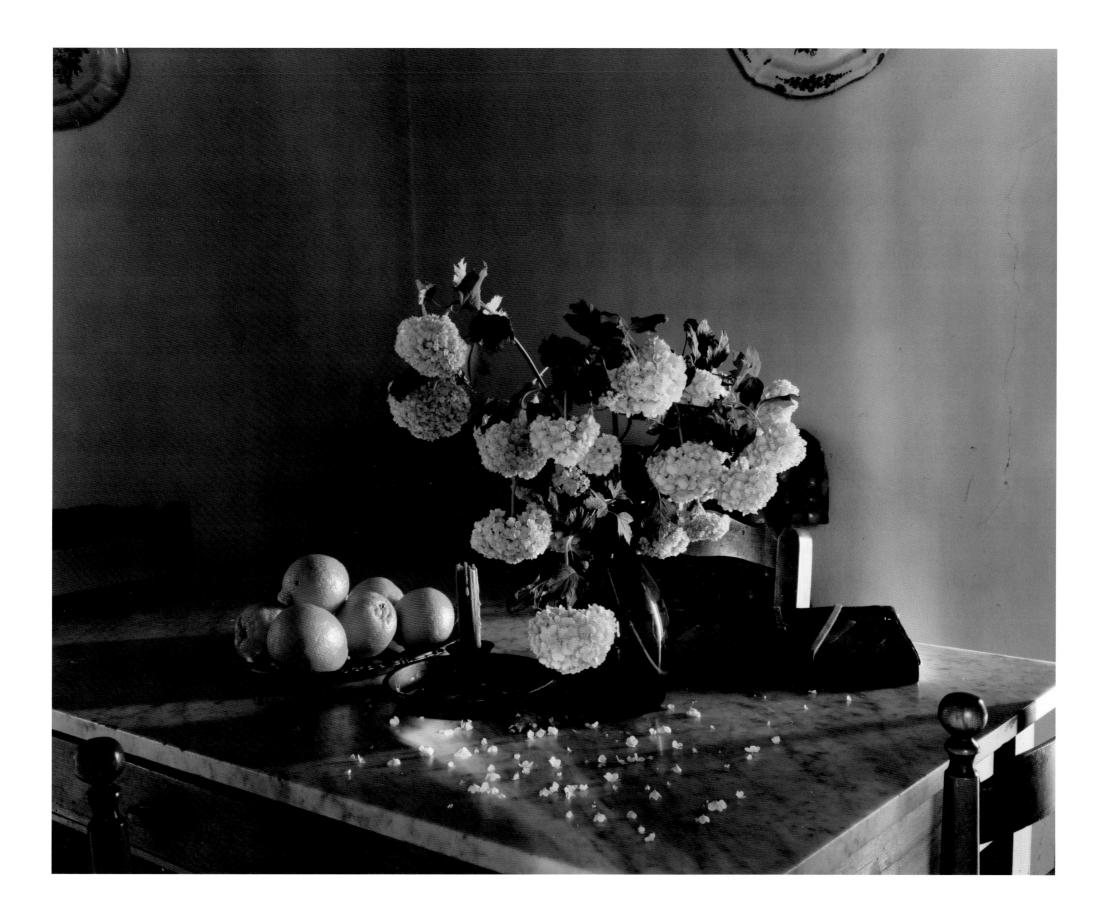

If only religion were this simple. To come to a place like this and be bathed in its soft, rosy light. What a baptism. No preaching, no superstition, no punishment. Light and silence. Only listen, and perhaps a prayer will come to your lips. Seventeen crosses, and on the eighteenth a whisper of Jesus, showing us the delicacy of surrender, at one with the instrument of his death.

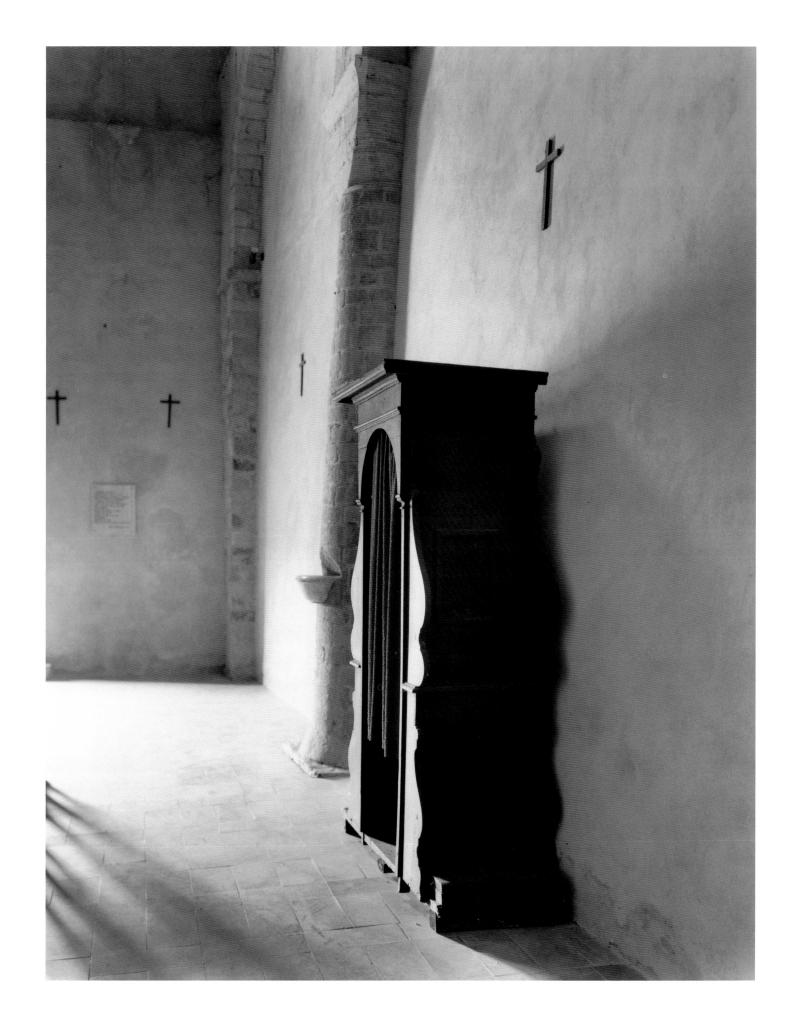

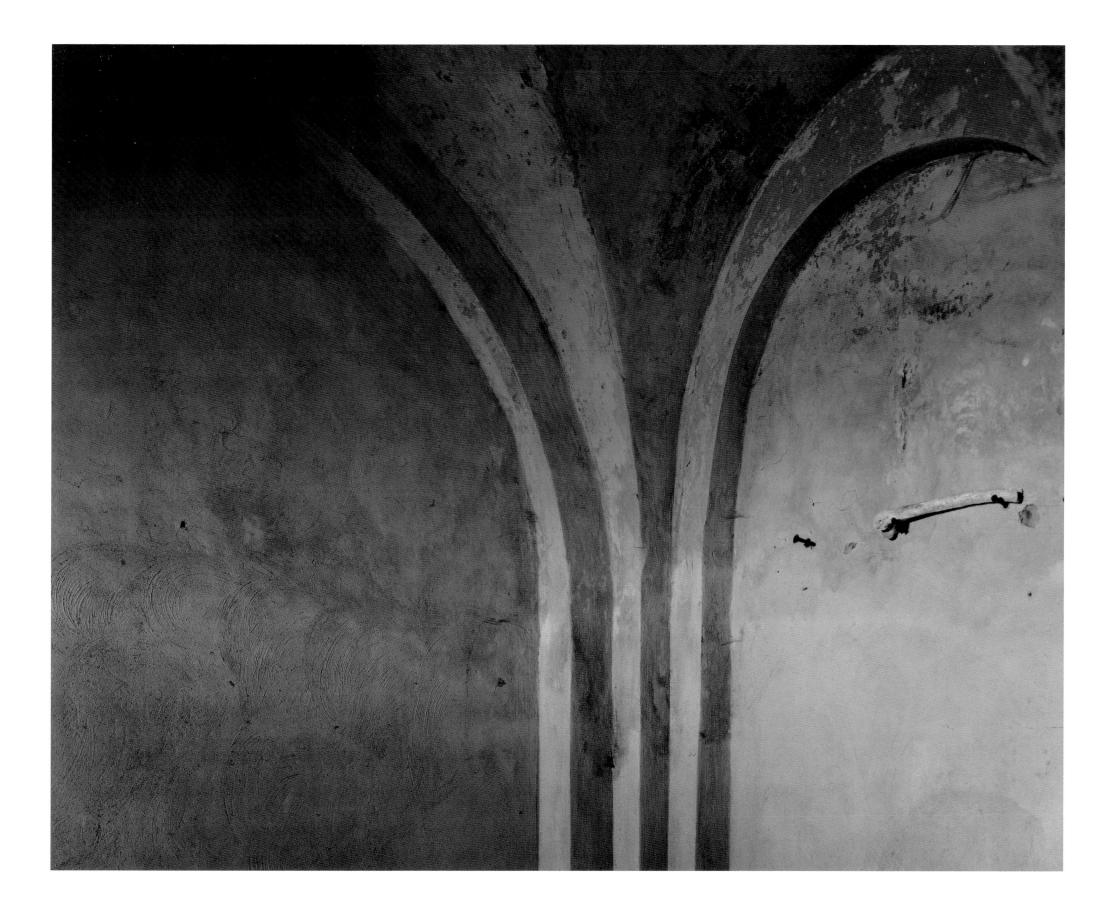

Space, time, light. Add to these worldly gifts the human gifts of labor, vision, and sensibility and you might just get a fireplace that is both cathedral and cave, temple and heart. I would wish to have sat before this one when the first flames rose, can imagine hands reaching toward the heat, the gigantic shadows leaping out from the hearth and dancing over faces and walls, ceiling and floor. You can almost hear the mighty roar and crackle of the wood—whole trunks burning, the smoke rising inside the ivory skin of the chimneybreast. To sit in this immense room is to lament all that we have abandoned in the name of progress.

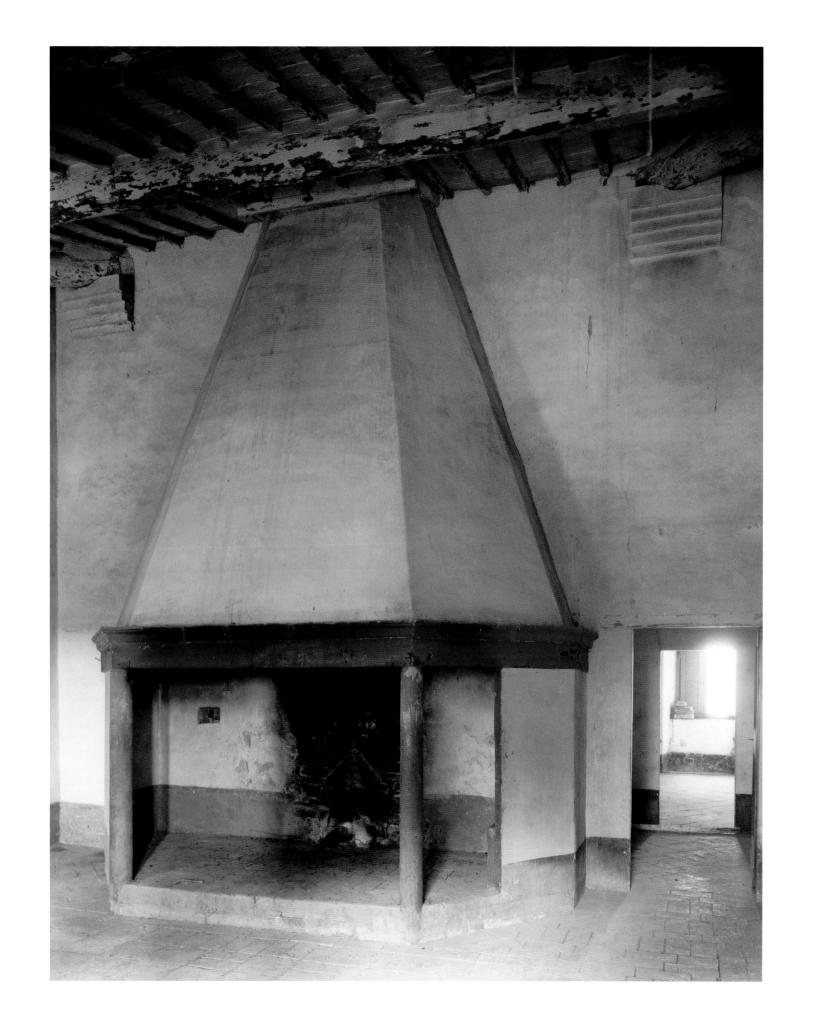

PLATE 30

OVERLEAF: PLATES 31 AND 32

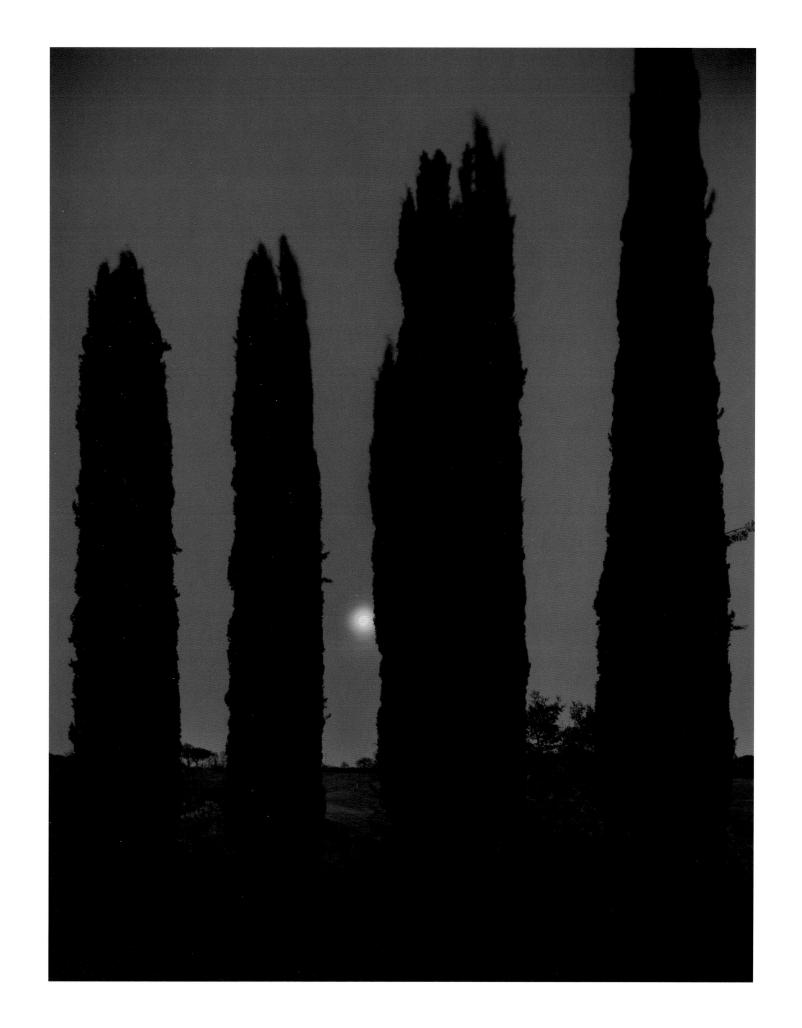

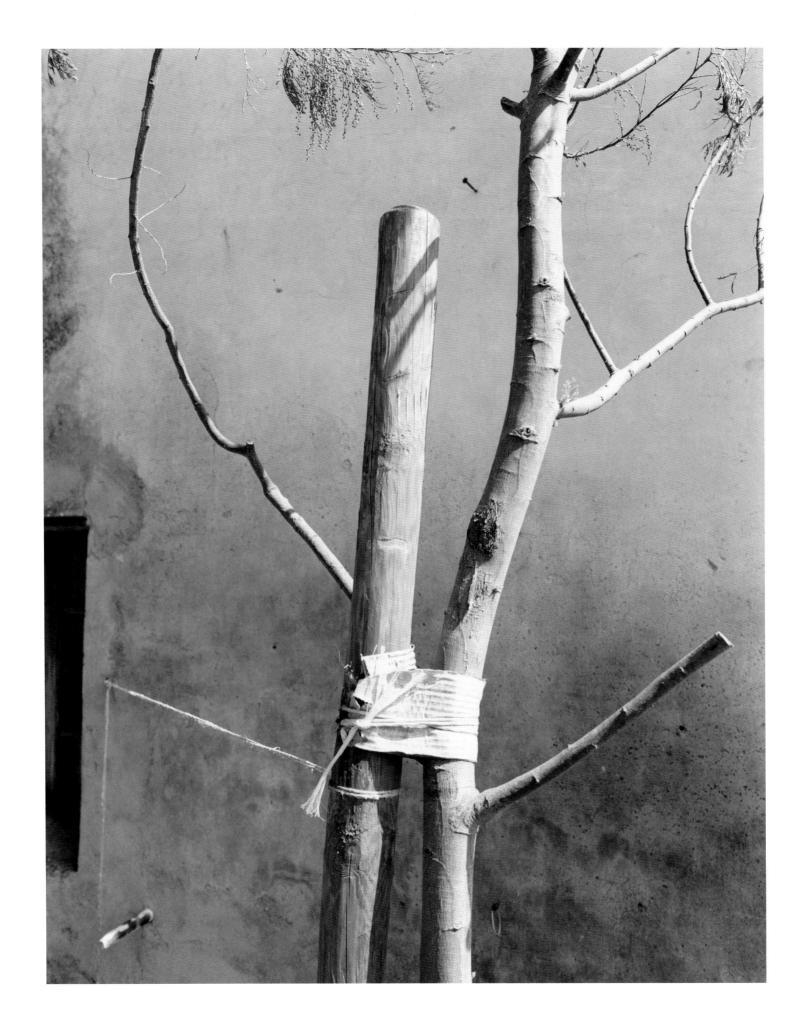

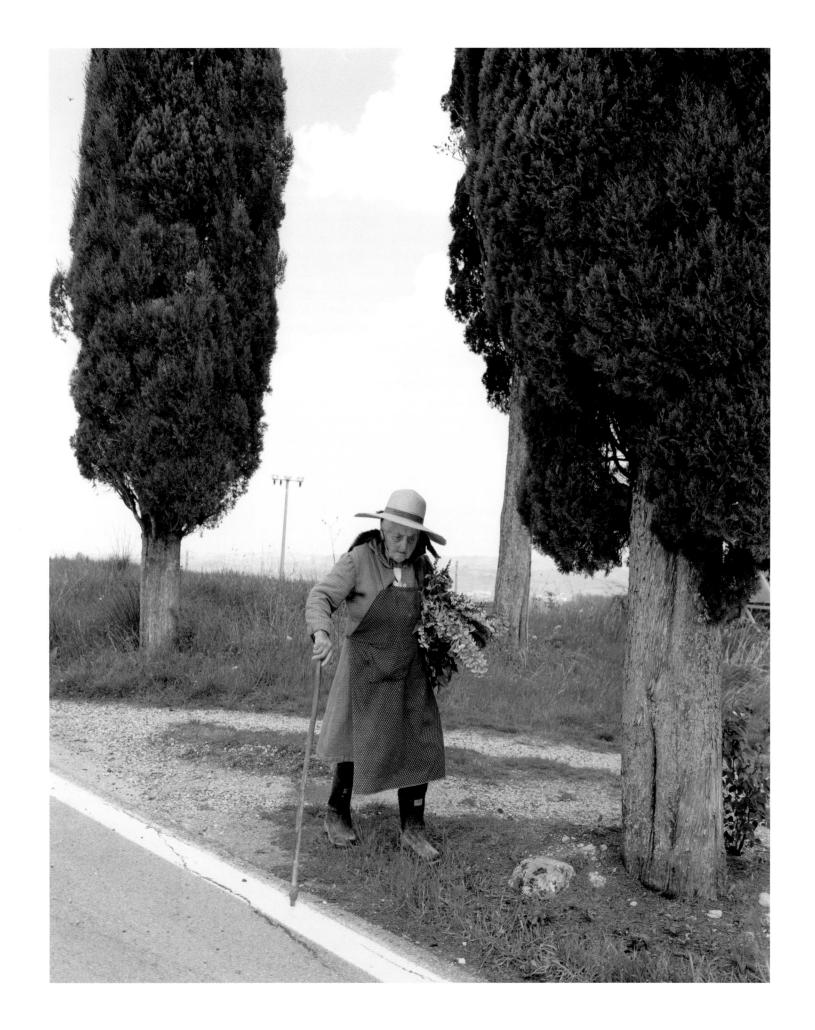

That is it that strives in us to become new?

To blossom and reach for the heavens before falling, falling to the earth? That tree, how many winters has it died to, and then, in the space between seasons, let its sap rise once again, unseen, valiant? Behold its glory now, alone, rooted to the same slope of field, its blossoms waving in the breeze.

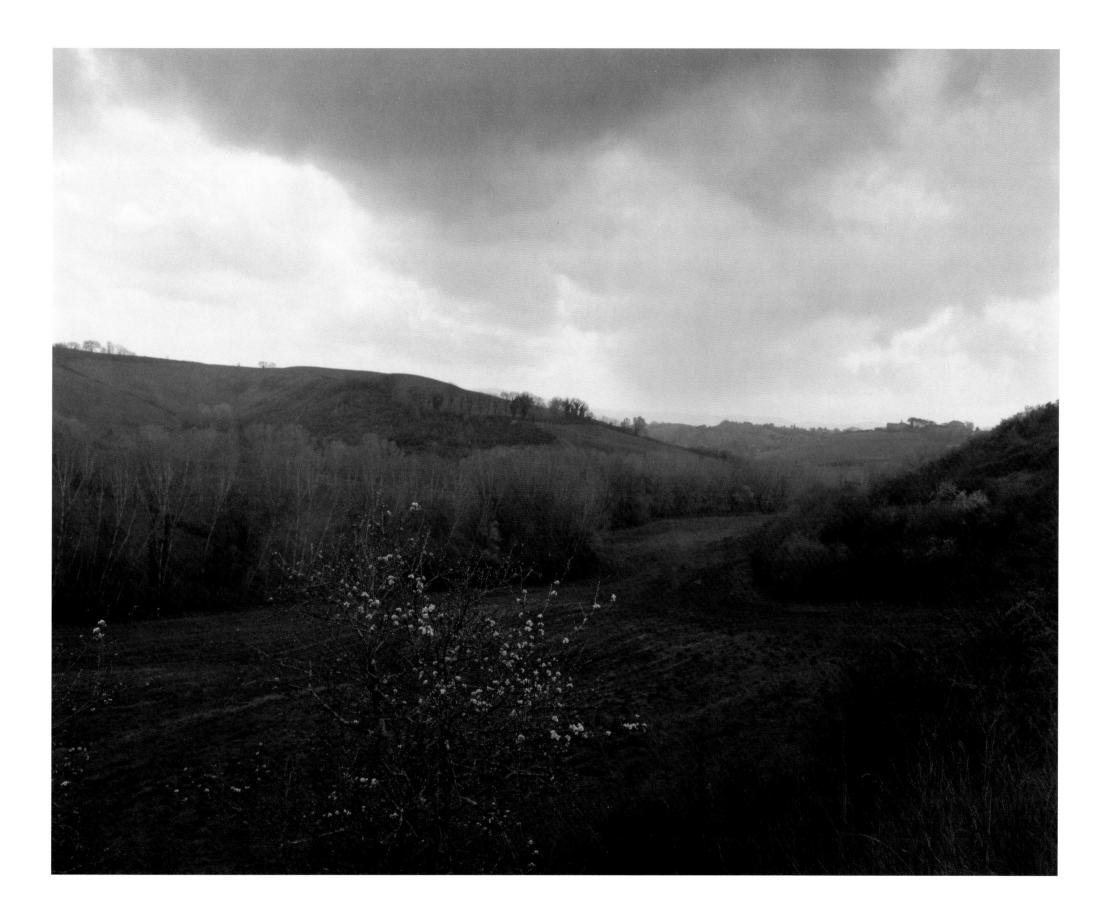

PLATE 34

Overleaf: Plates 35, 36, and 37

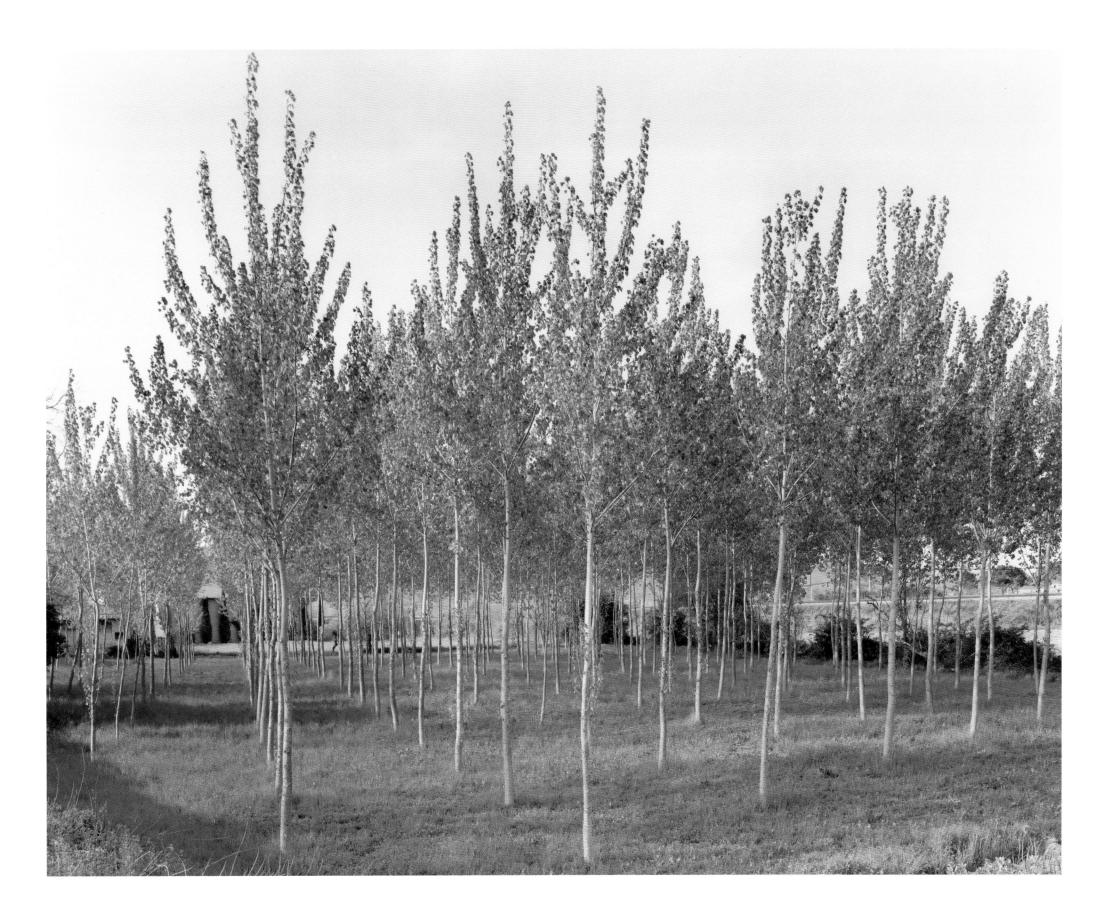

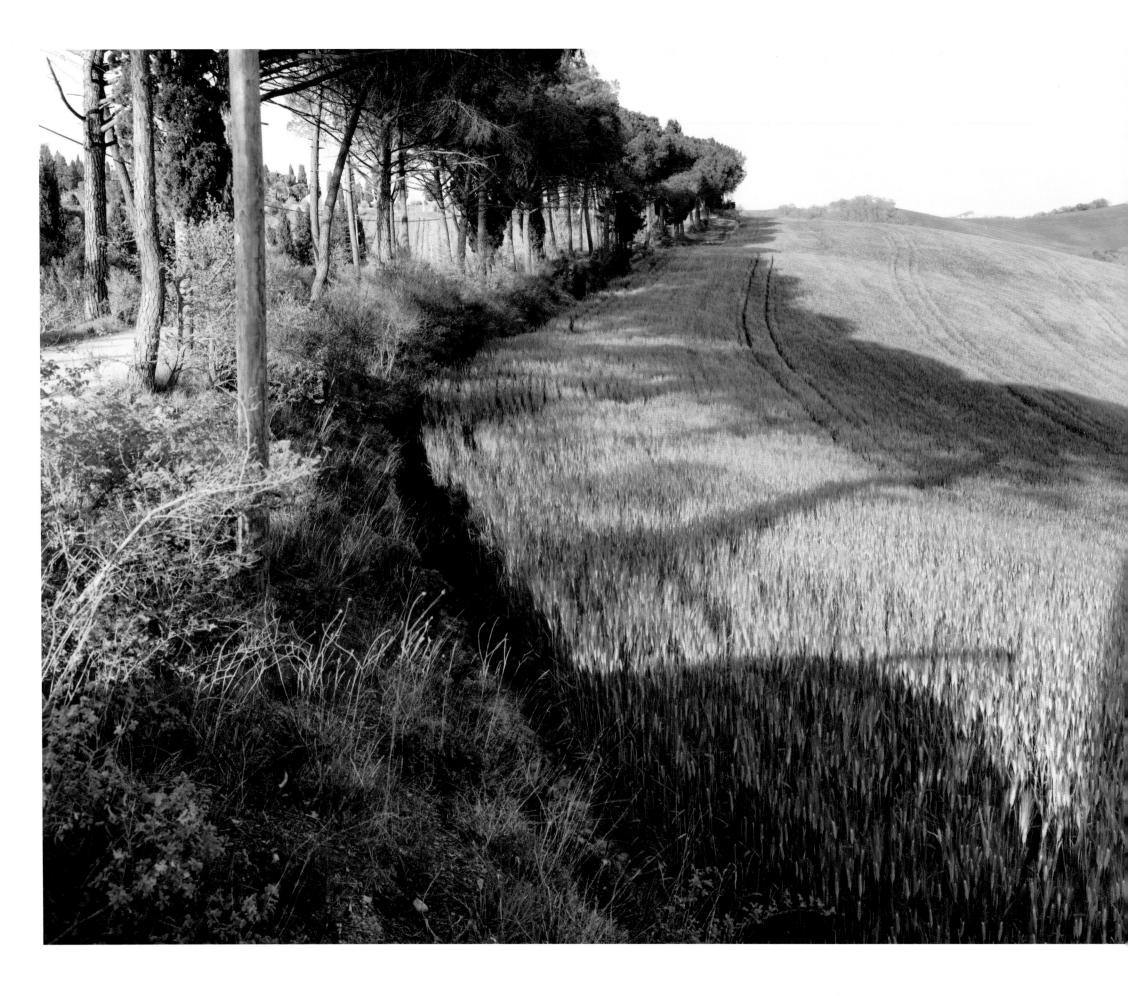

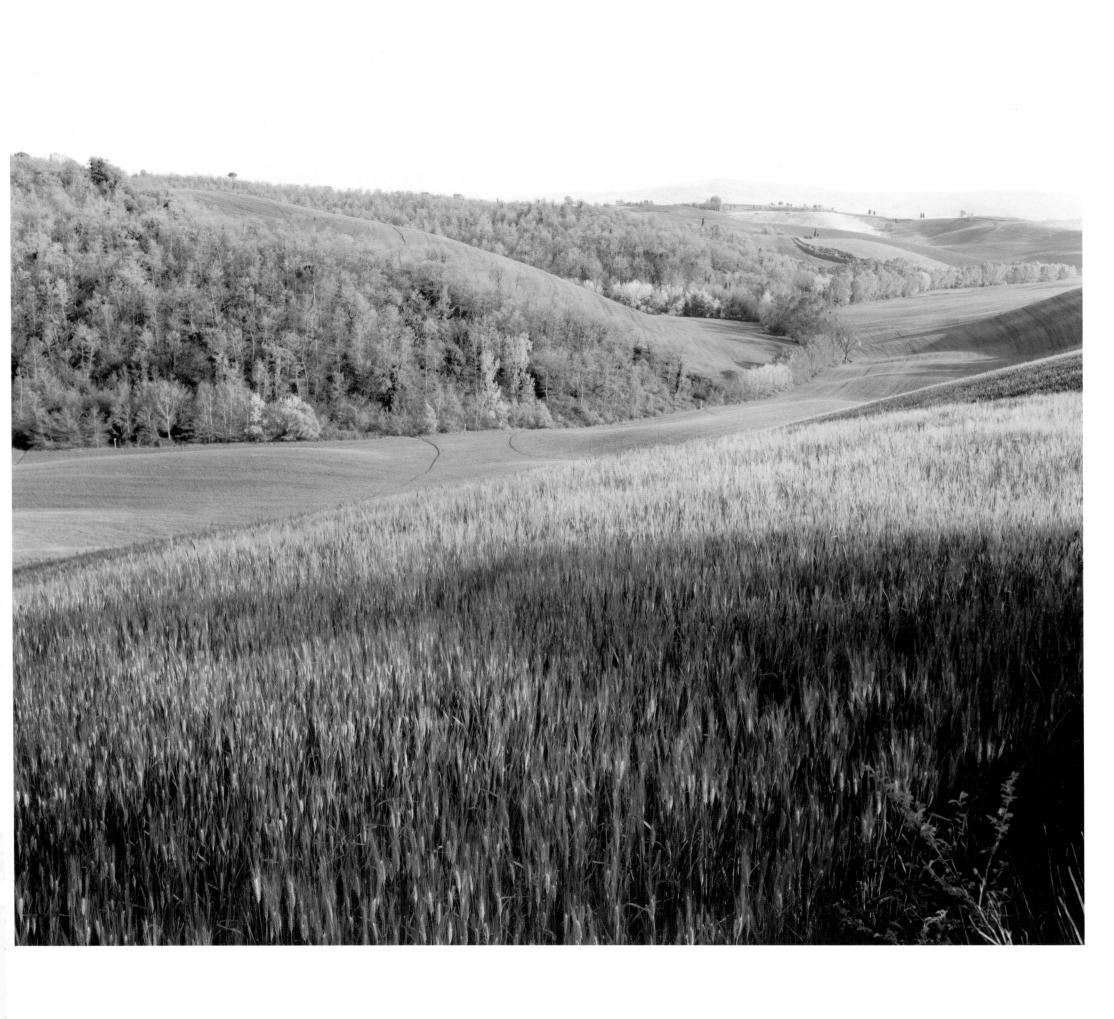

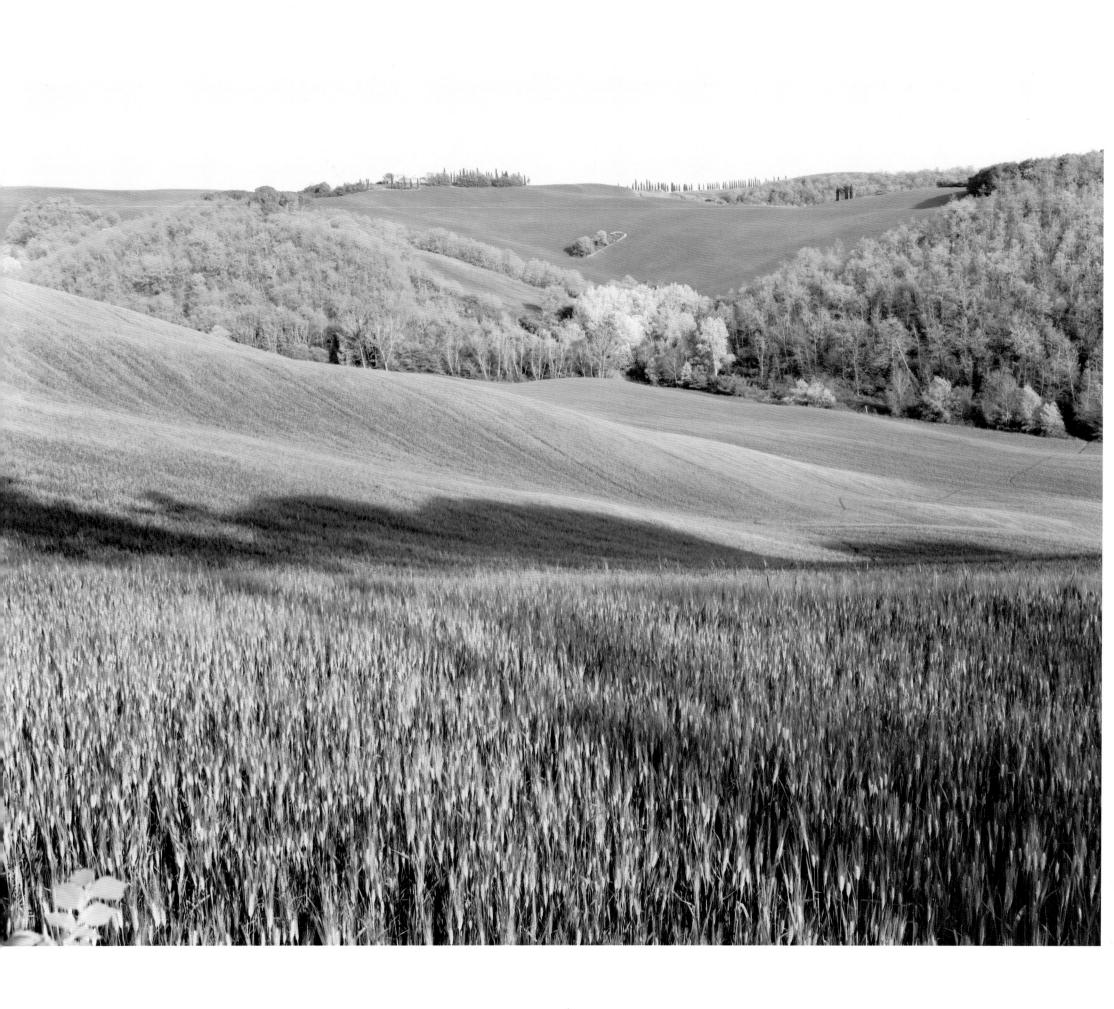

The poppies are coming, their bloody heads pricking

the landscape. And so spring journeys, emerging from winter with snowy blossoms of hawthorn, progressing through an enviable vocabulary of greens, and now, finally, the red-hot poppies heralding the arrival of summer. White, green, red...ltaly's flag plucked straight from the earth.

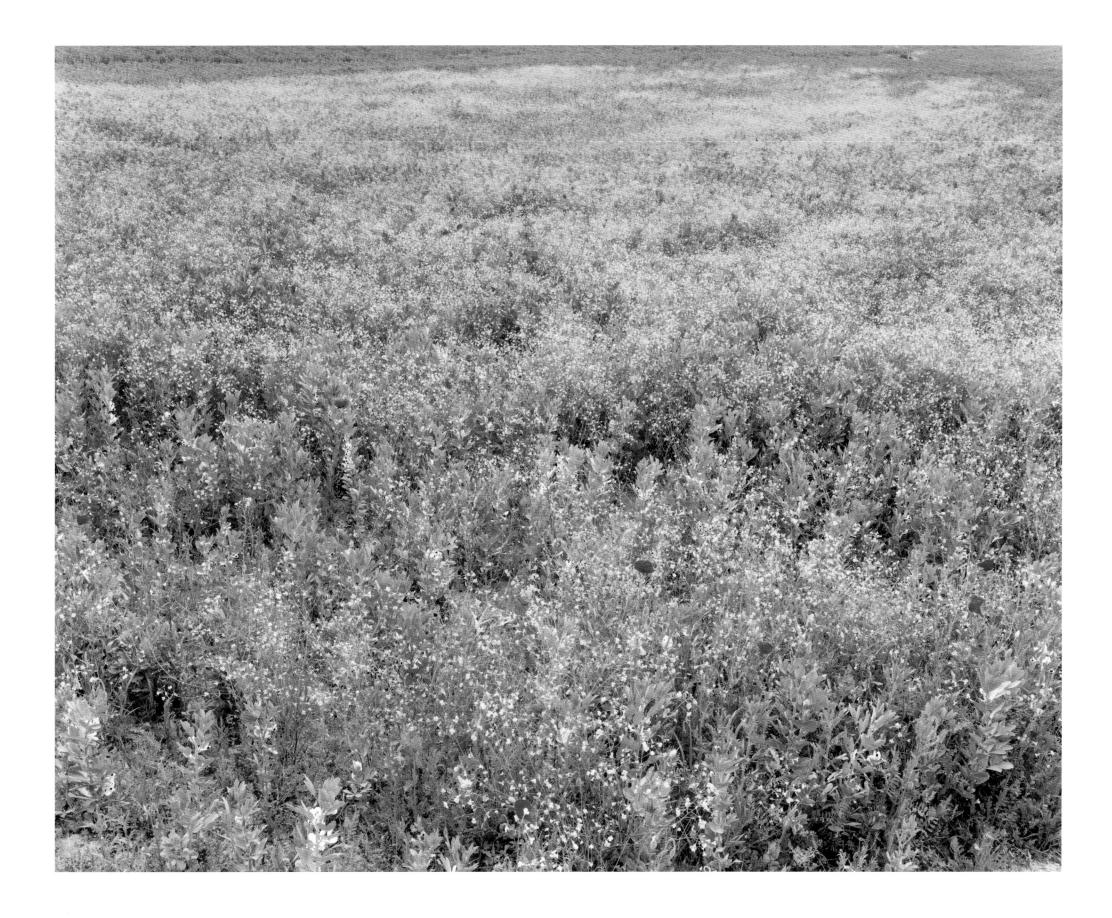

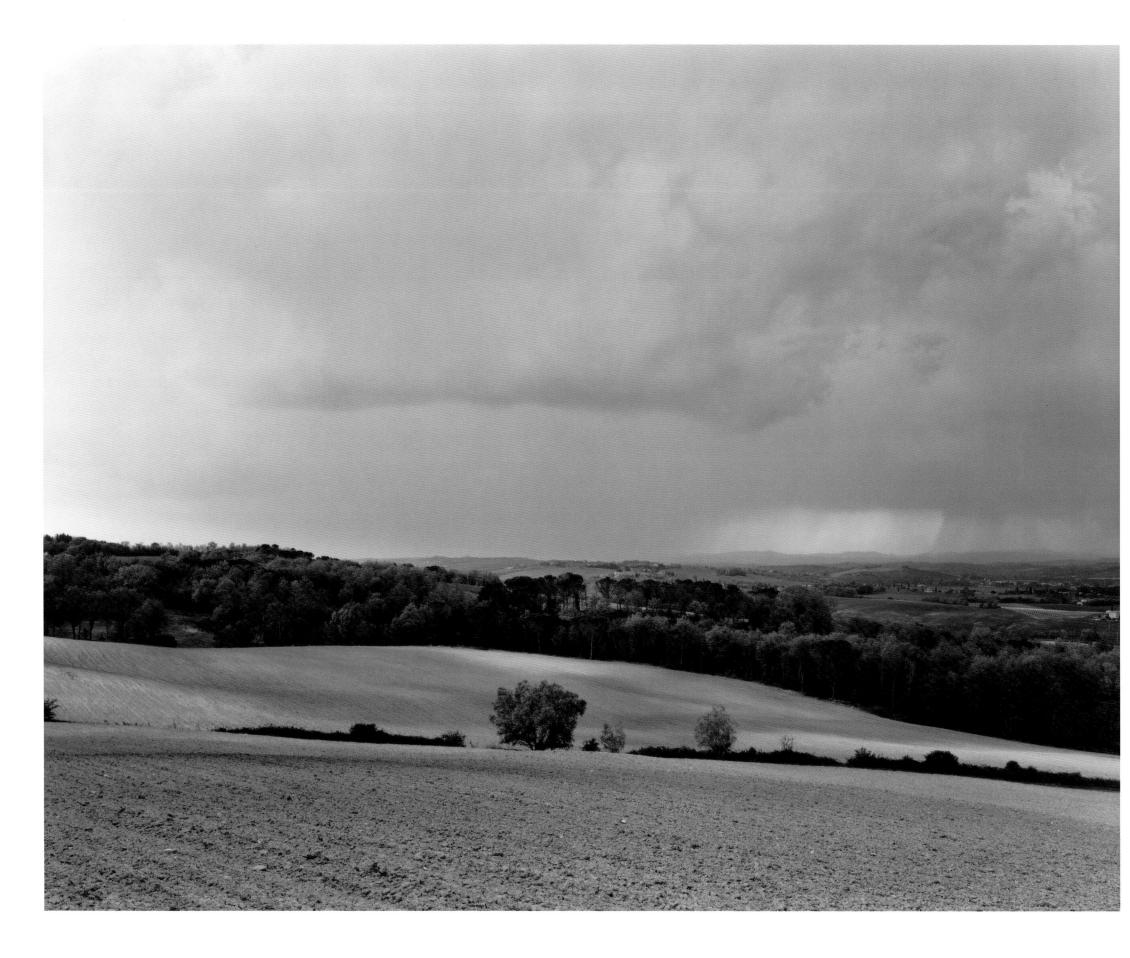

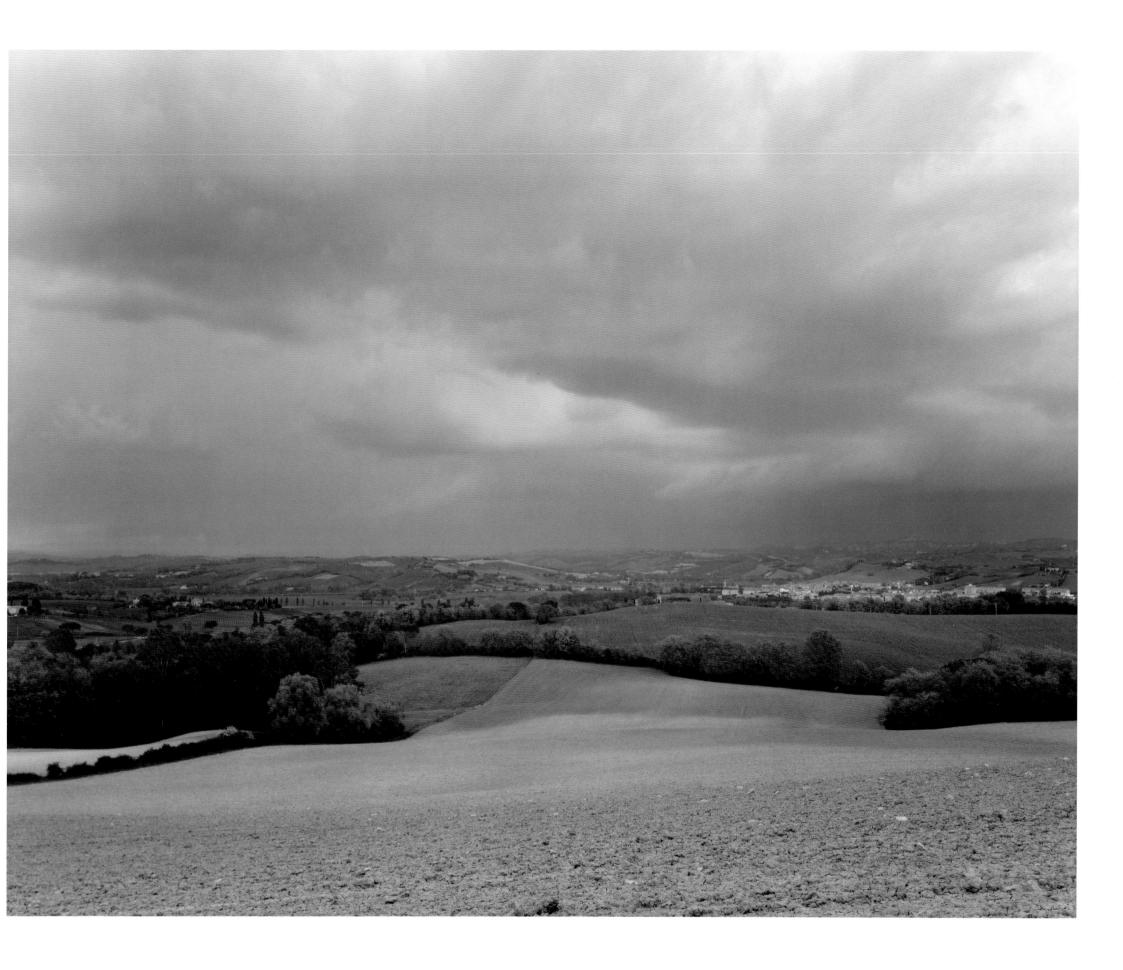

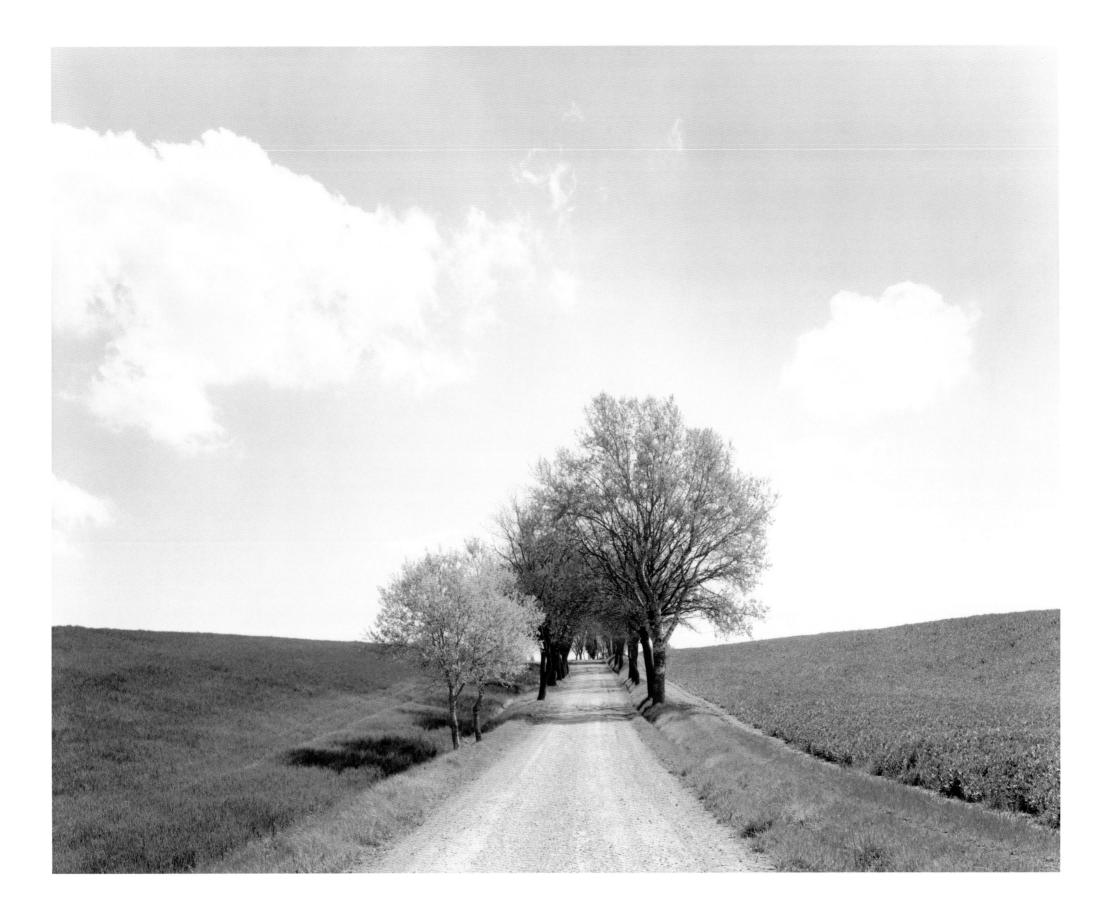

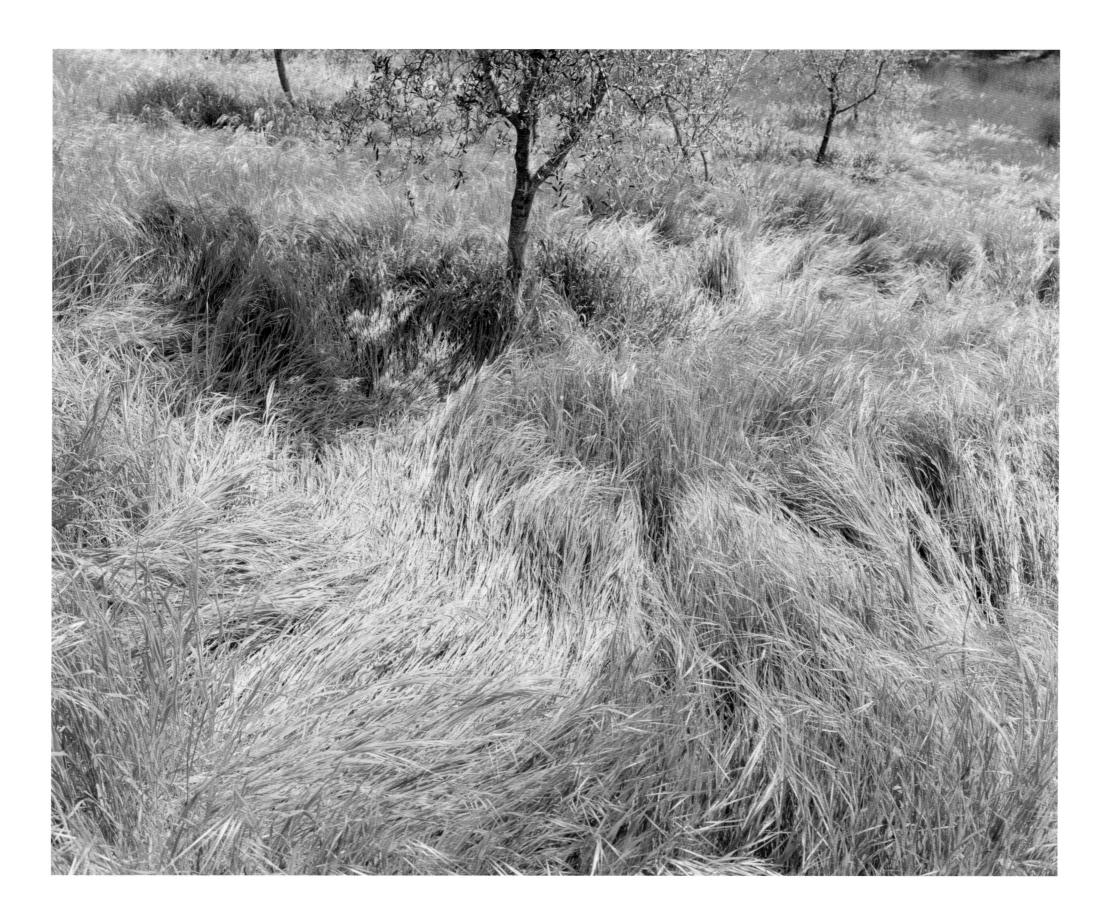

S U M M E R

The long shadows of a summer evening meet the remains of the day's golden light, the wheat lit from deep within. This strawberry blonde crop, tousled from an afternoon of wind, has come to rest in all its glorious dishevelment beneath the sky. Ah, summer, season of false eternity, the season that cradles our childhood with some glad memory of possibility. The length and breadth and depth of those days stay with us forever, as if the sun had burned the memories into our skin, so that now all one need do is shed a layer of clothing and feel again the fullness of life.

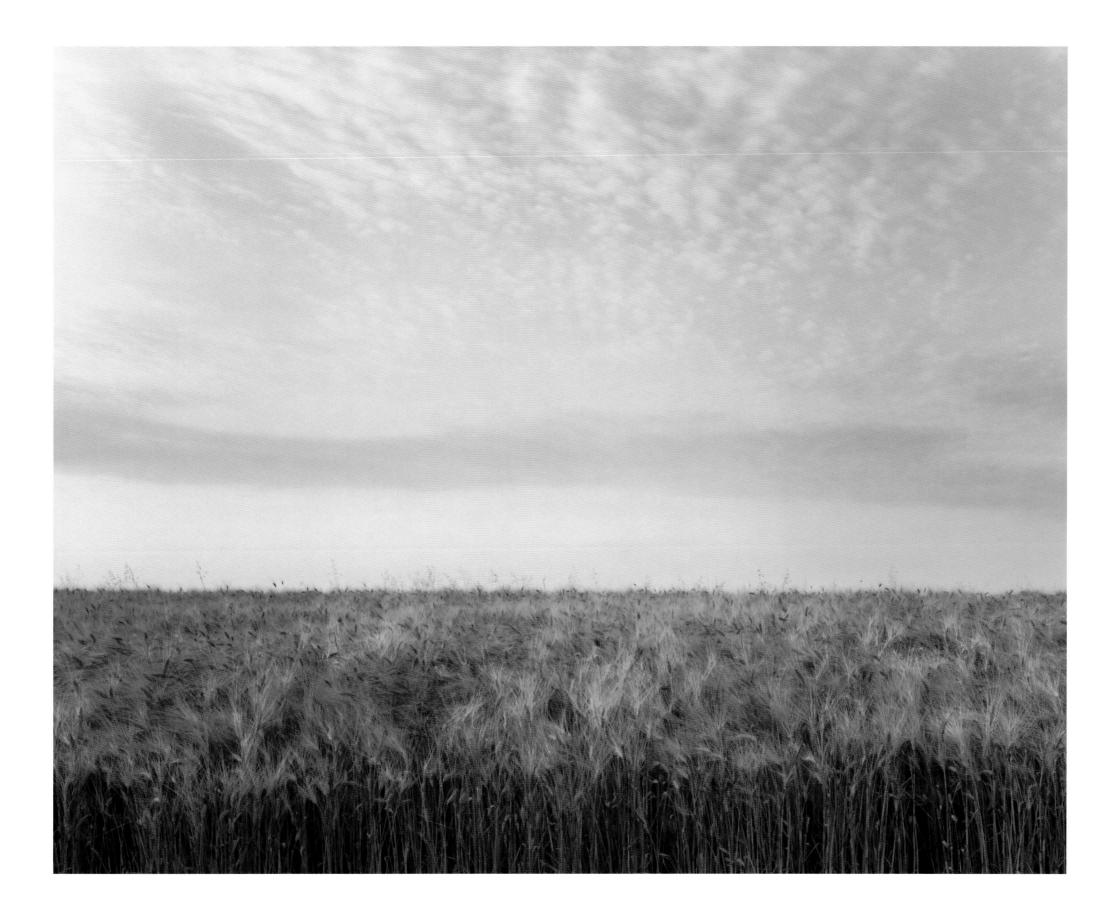

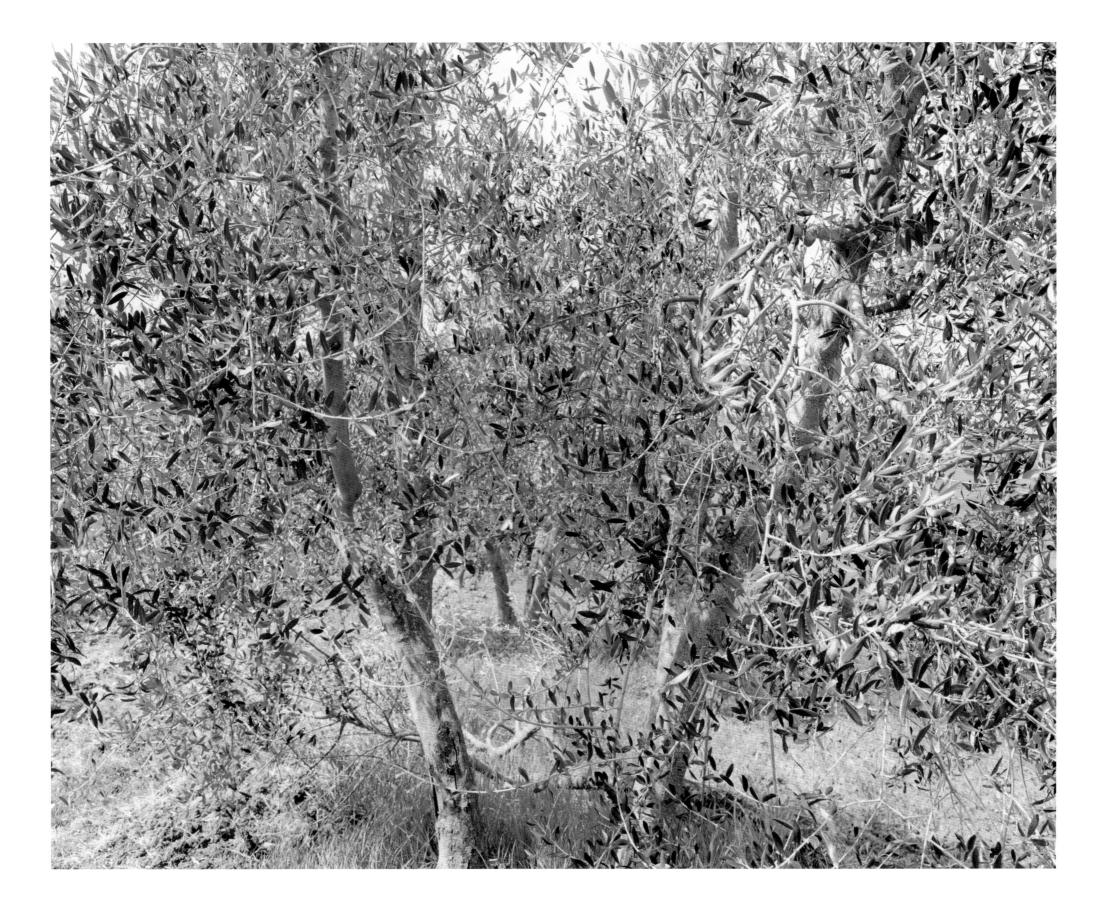

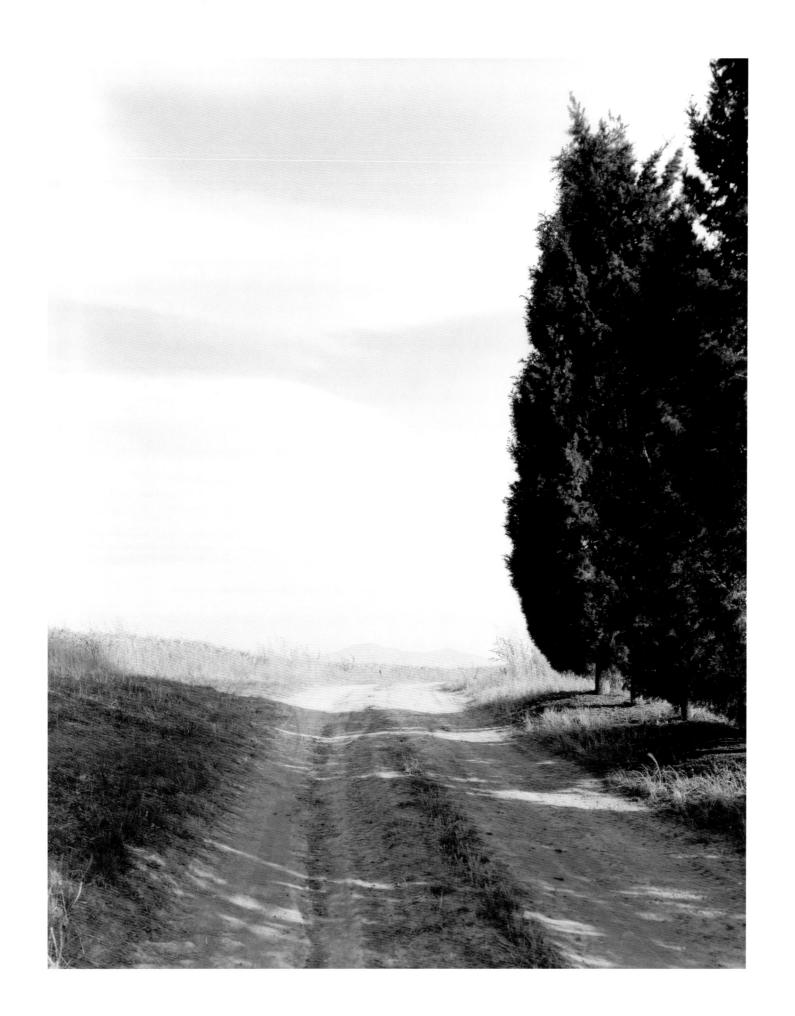

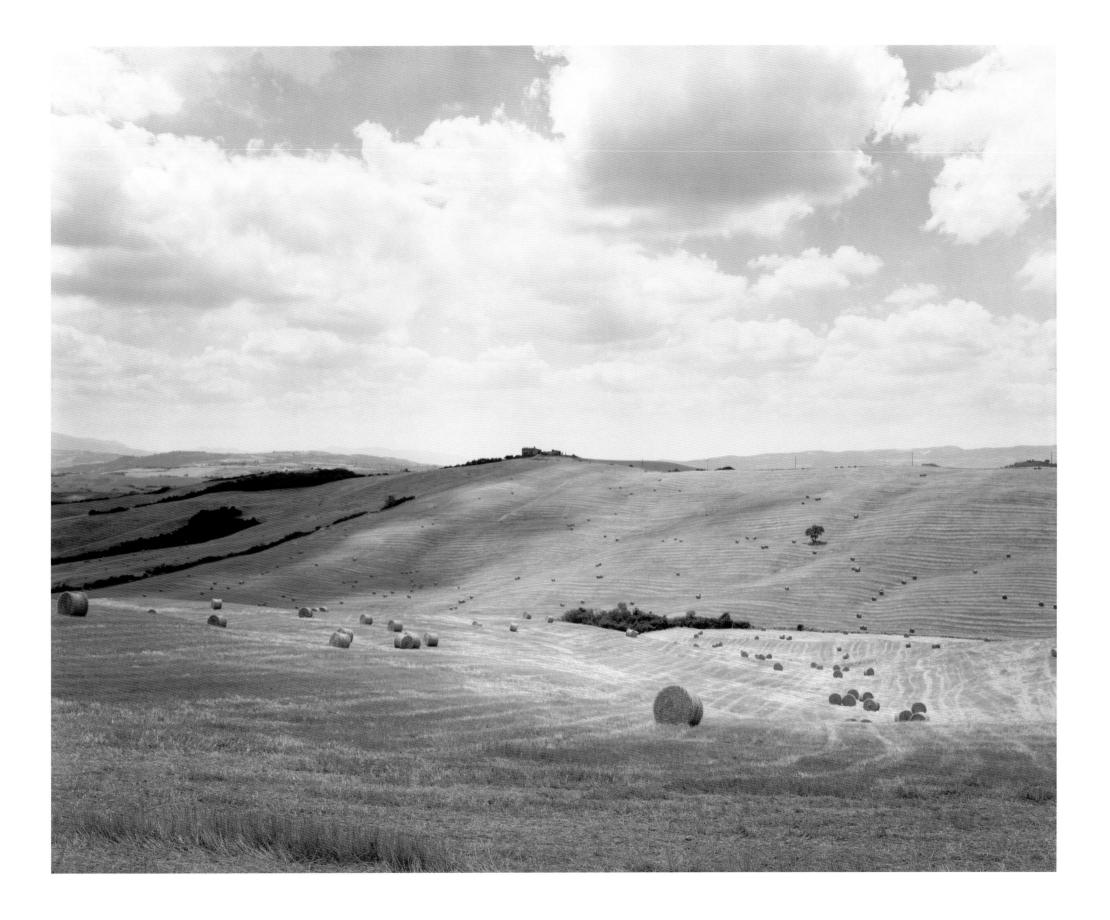

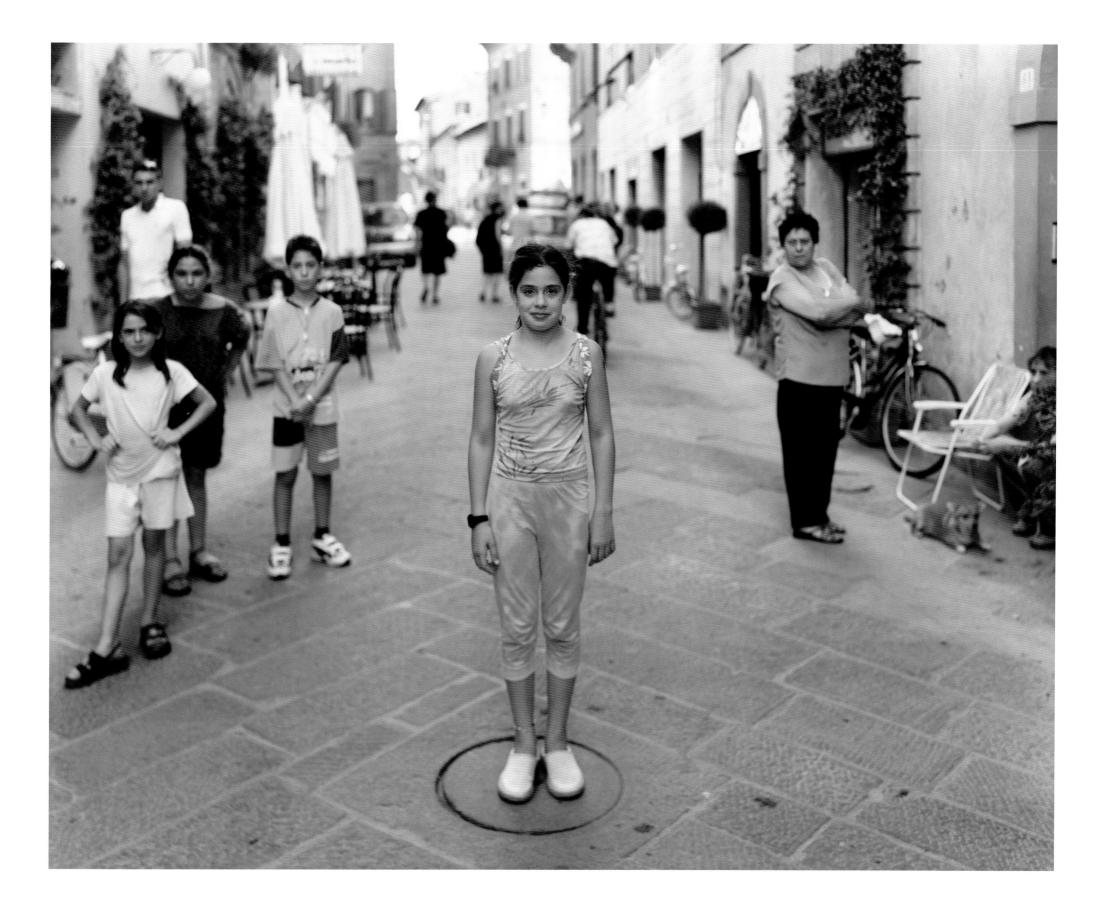

are still the contemporary horse. Everyone has one. The women in their skirts carry provisions.

Teenage boys, practicing for the circus, sometimes carry as many as three or four friends, all hanging off handlebars and saddles... and each other. And there's always a young prince riding past with his princess standing behind him, her hands on his shoulders, her young body like a figure on a ship's bow, poised, hair streaming. In the evening, the older men ride out of town in groups, to admire the sunset. But perhaps my favorites are the young mothers with their toddlers proudly displayed on the handlebars, stopping every few yards down the street to receive the abundant, daily admiration of their produce. It's all here, light, shadow, youth, age...here, and then gone.

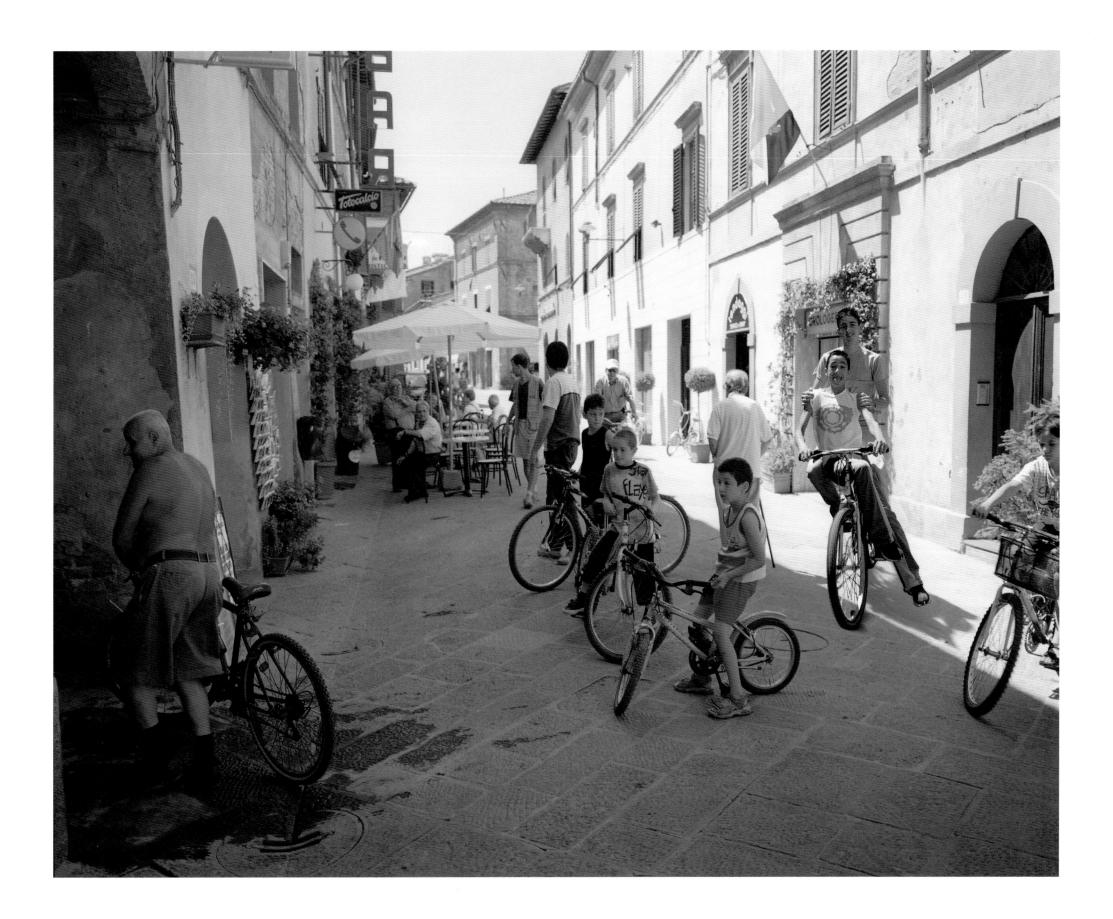

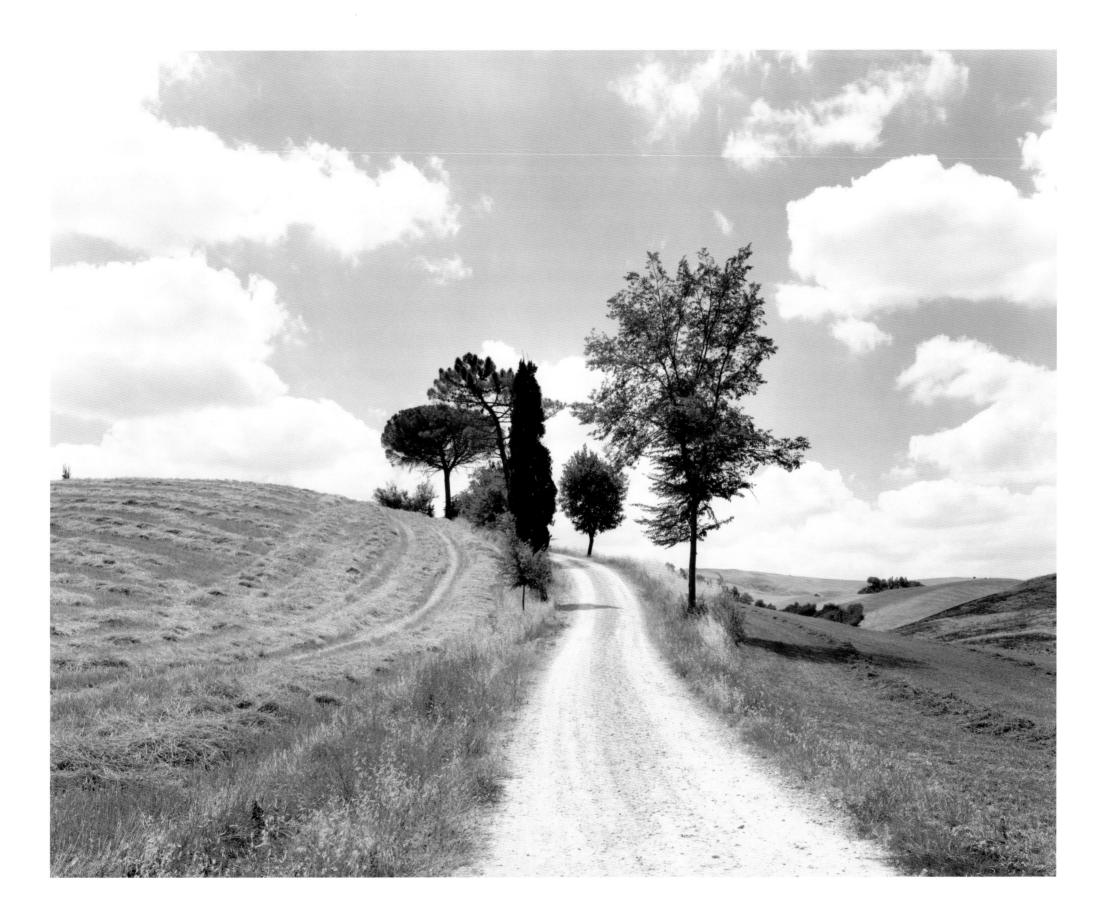

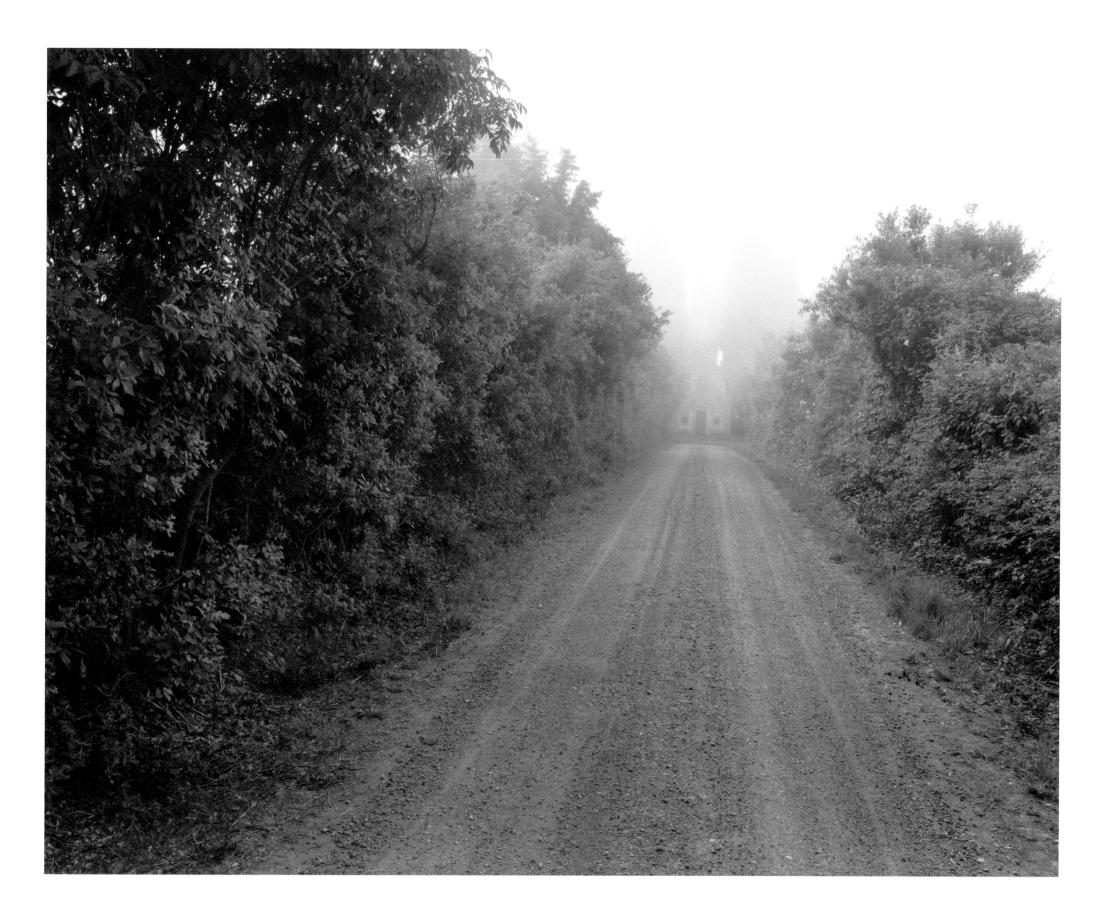

PLATE 5 I

OVERLEAF: PLATES 52 AND 53

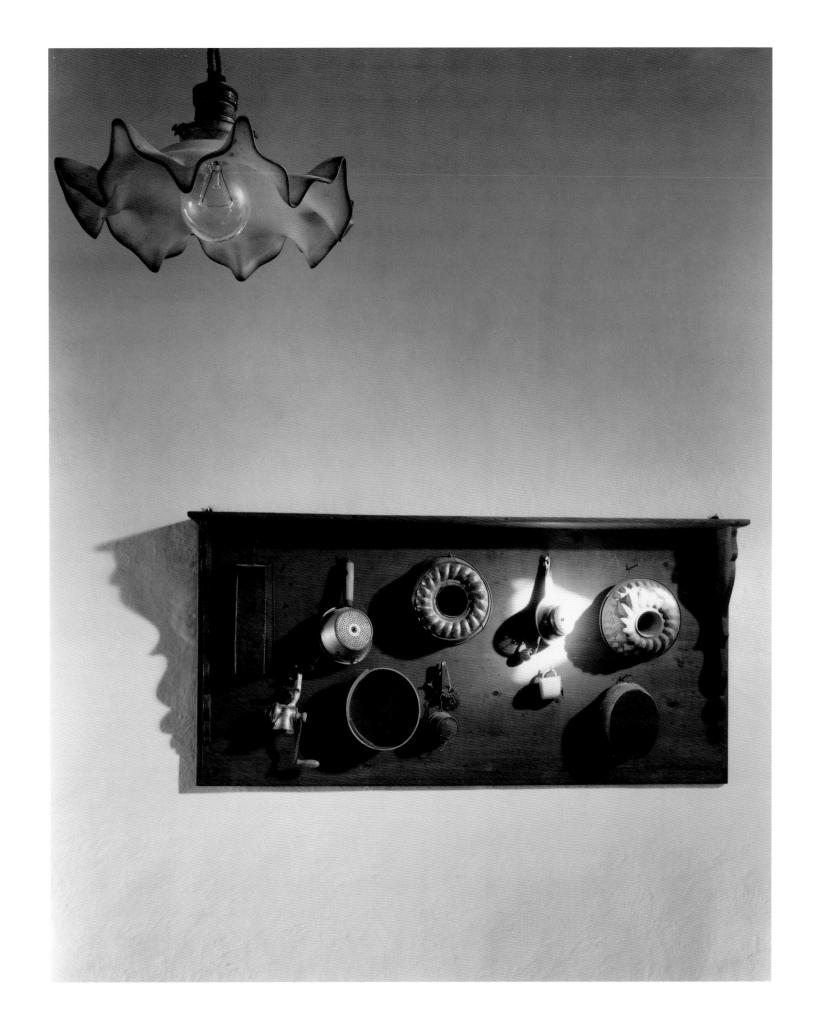

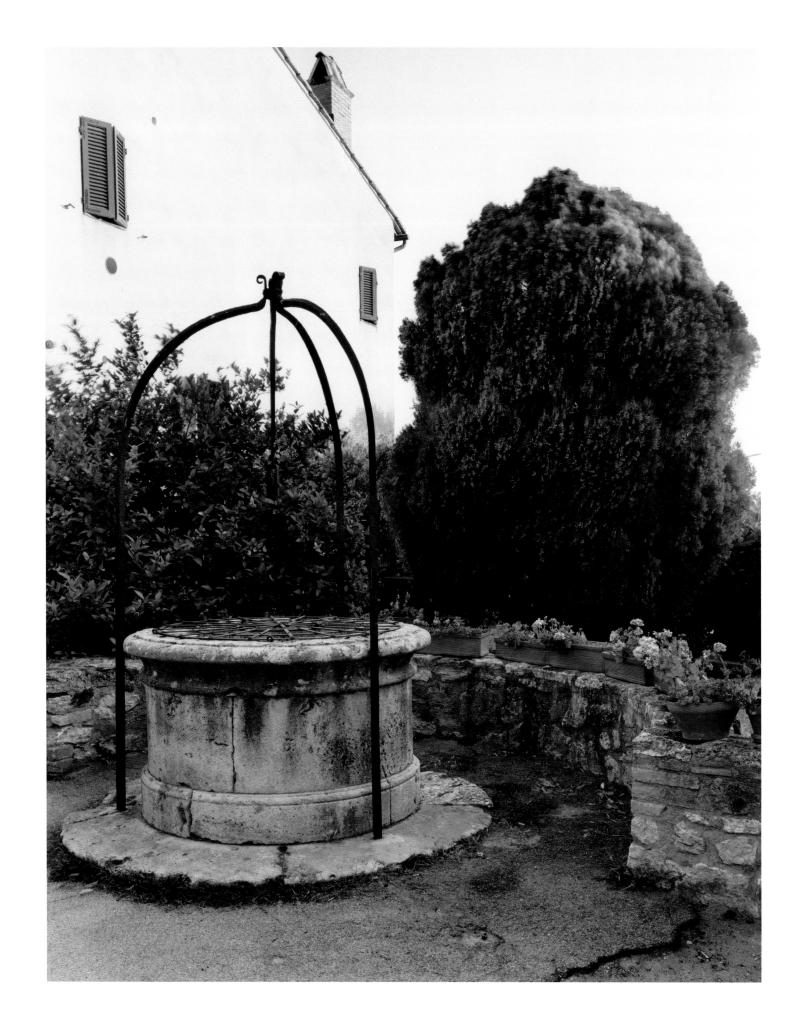

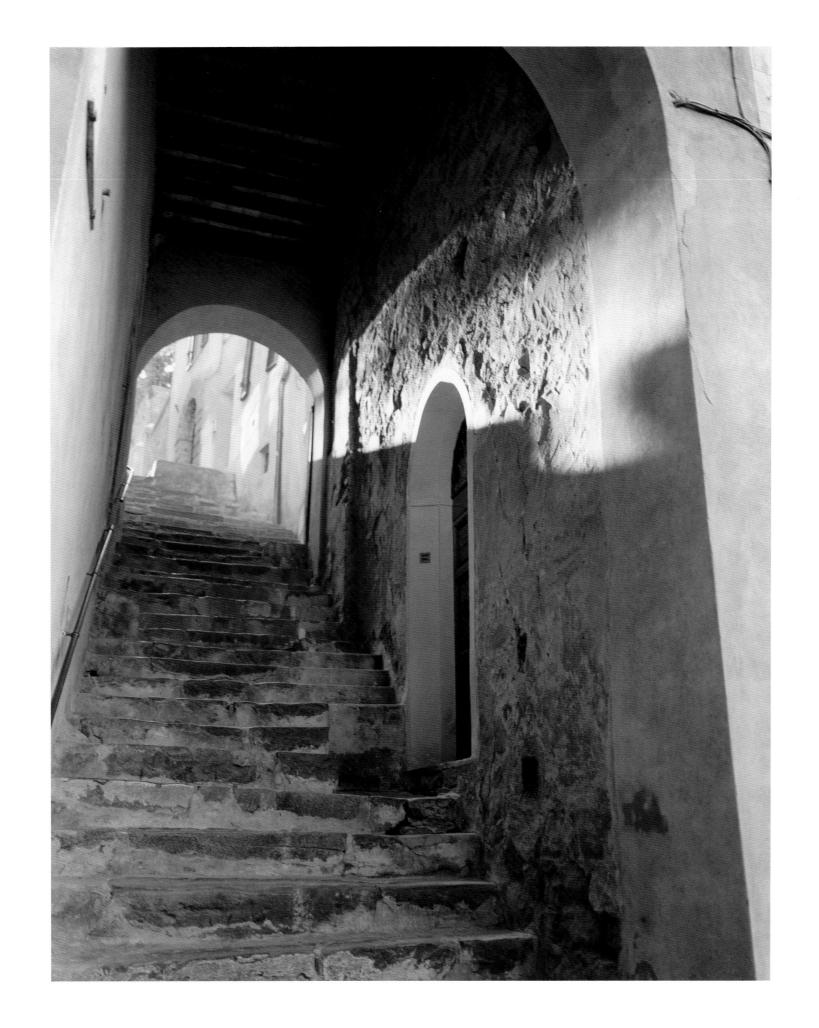

There are moments and places like this where nature is still so awesome that we experience ourselves cut down to size. Yet the experience is not one of diminishment, but of relief and harmony. To feel oneself in direct relationship to the planet is to experience a profound connection, and in these moments we understand the true meaning of belonging.

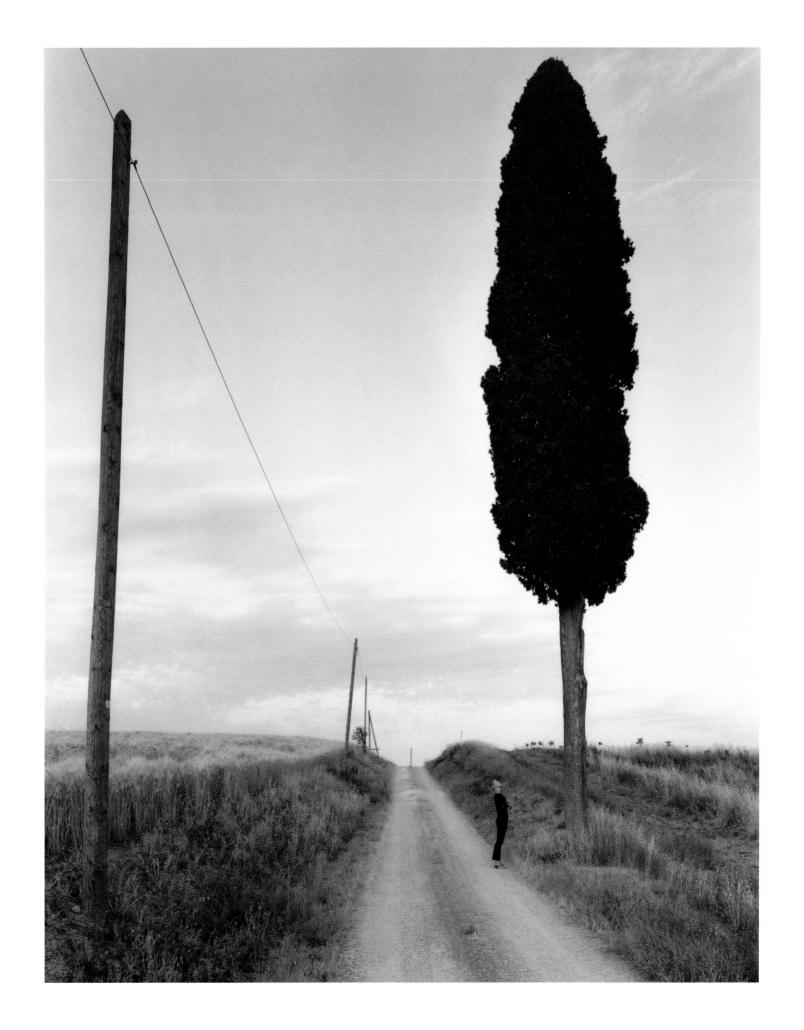

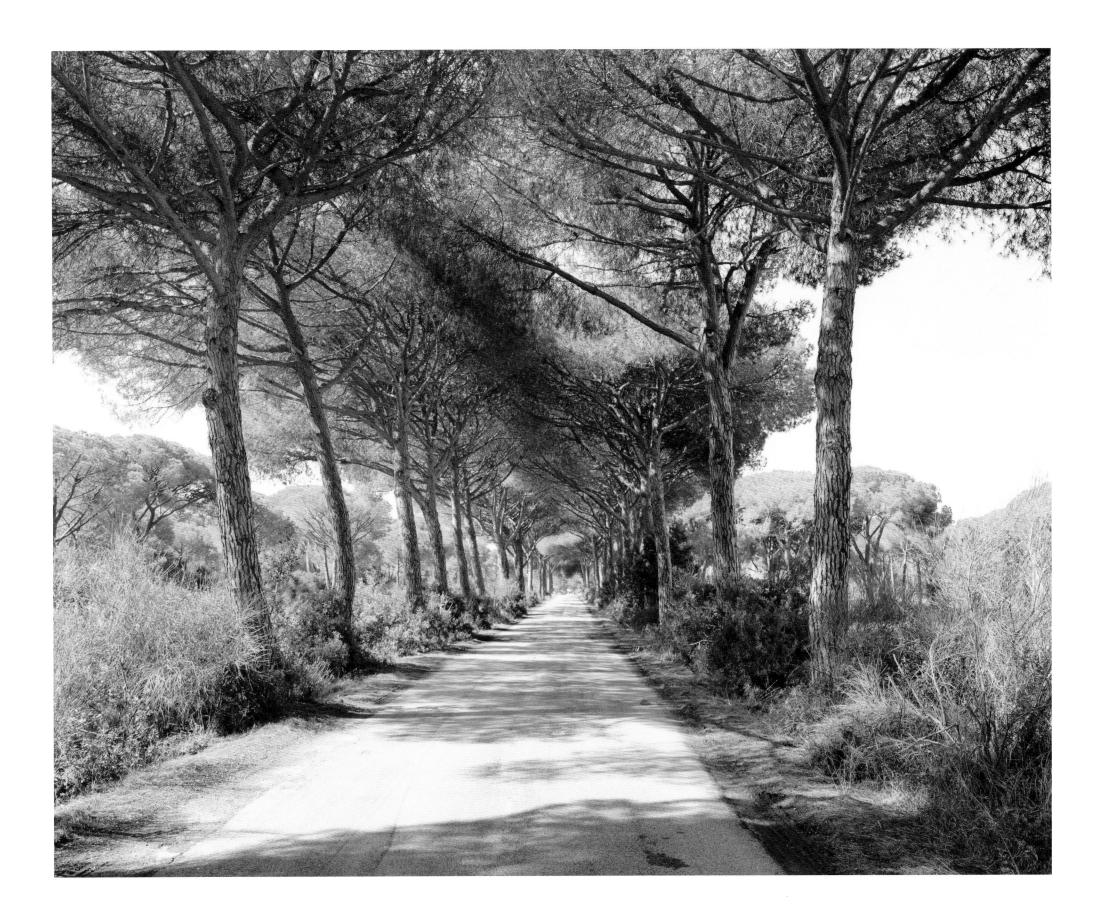

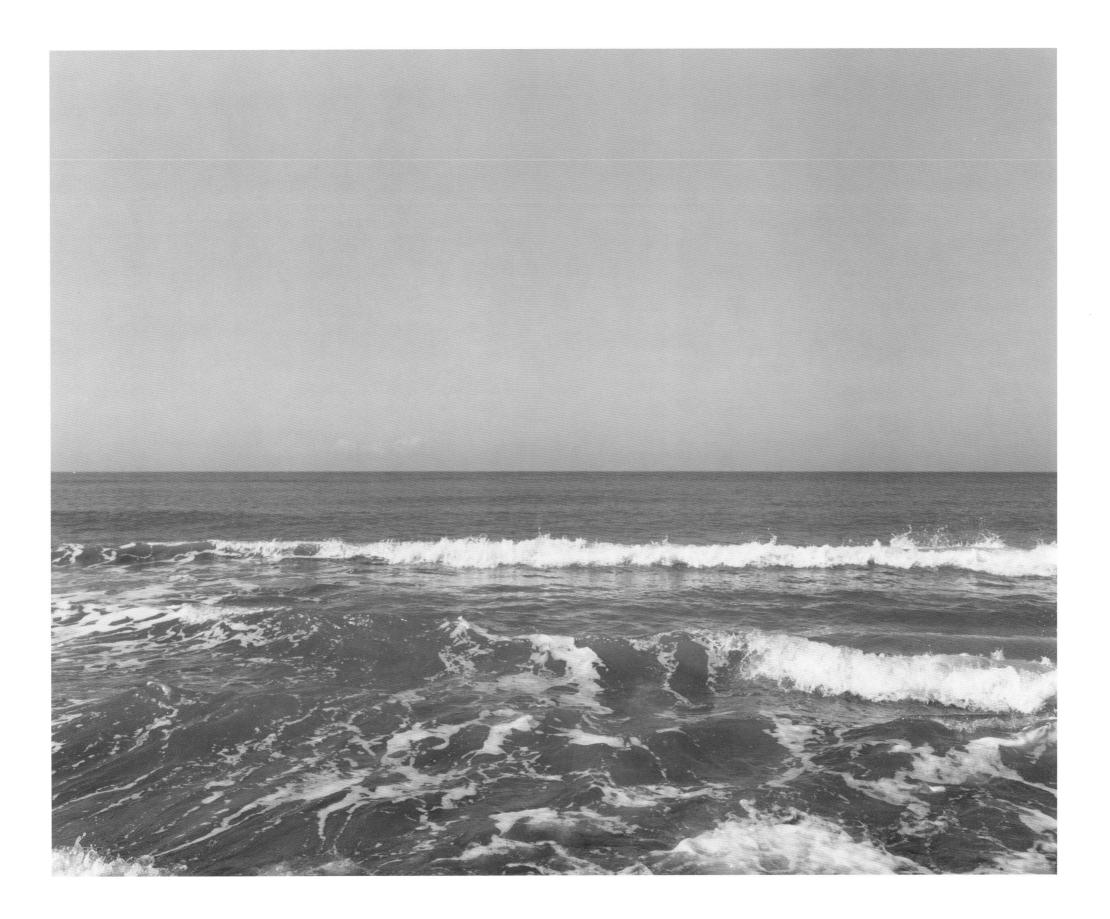

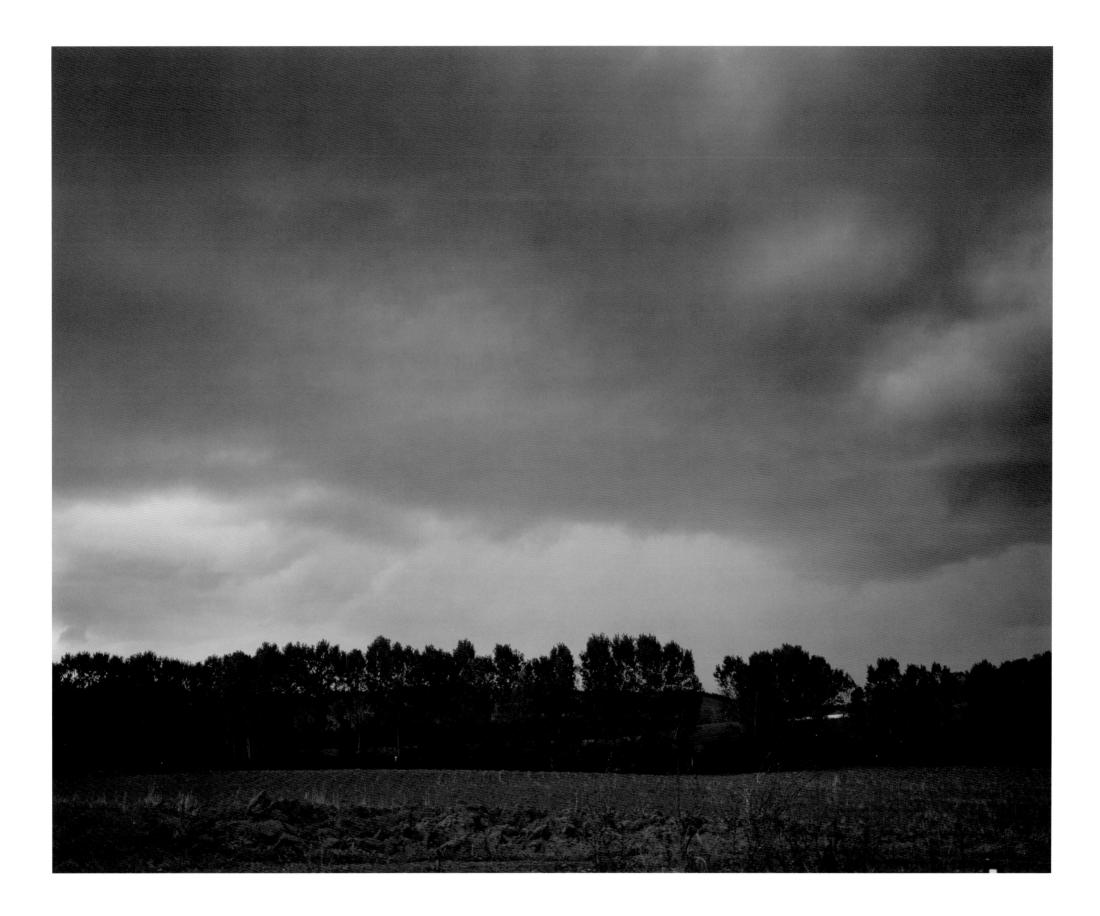

A U T U M N

hey call him Peppo. He tells us he is gleaning the cobs to feed his animals and we are reminded, once again, of the life lived in honor of, and participation with, the cycles of the earth. Then he tells us he was a prisoner of war. Five years, in Germany. He tells us this in the same manner he tells of feeding his animals. His face is benign. We try to imagine his return to this, after five years like that. It is obvious the two things don't go together. His son comes over to say hello. This is my father, he says, he was a prisoner of war, five years.

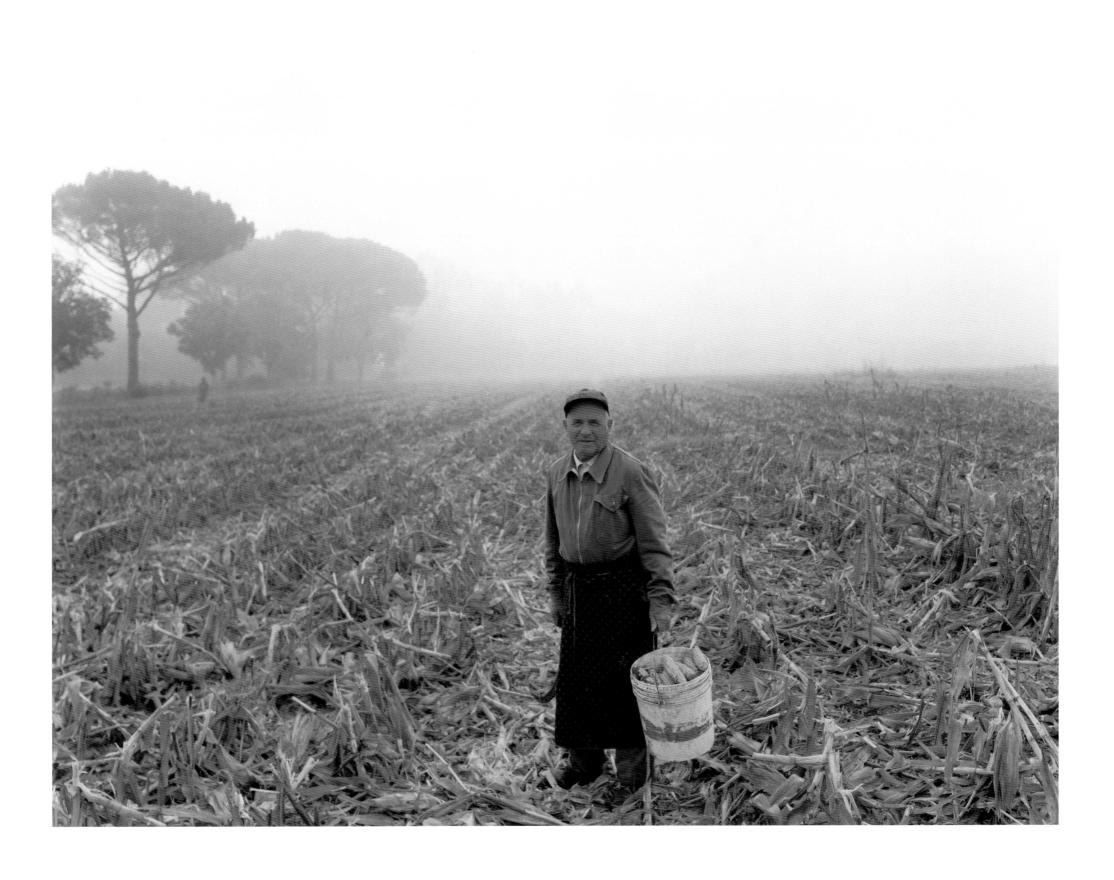

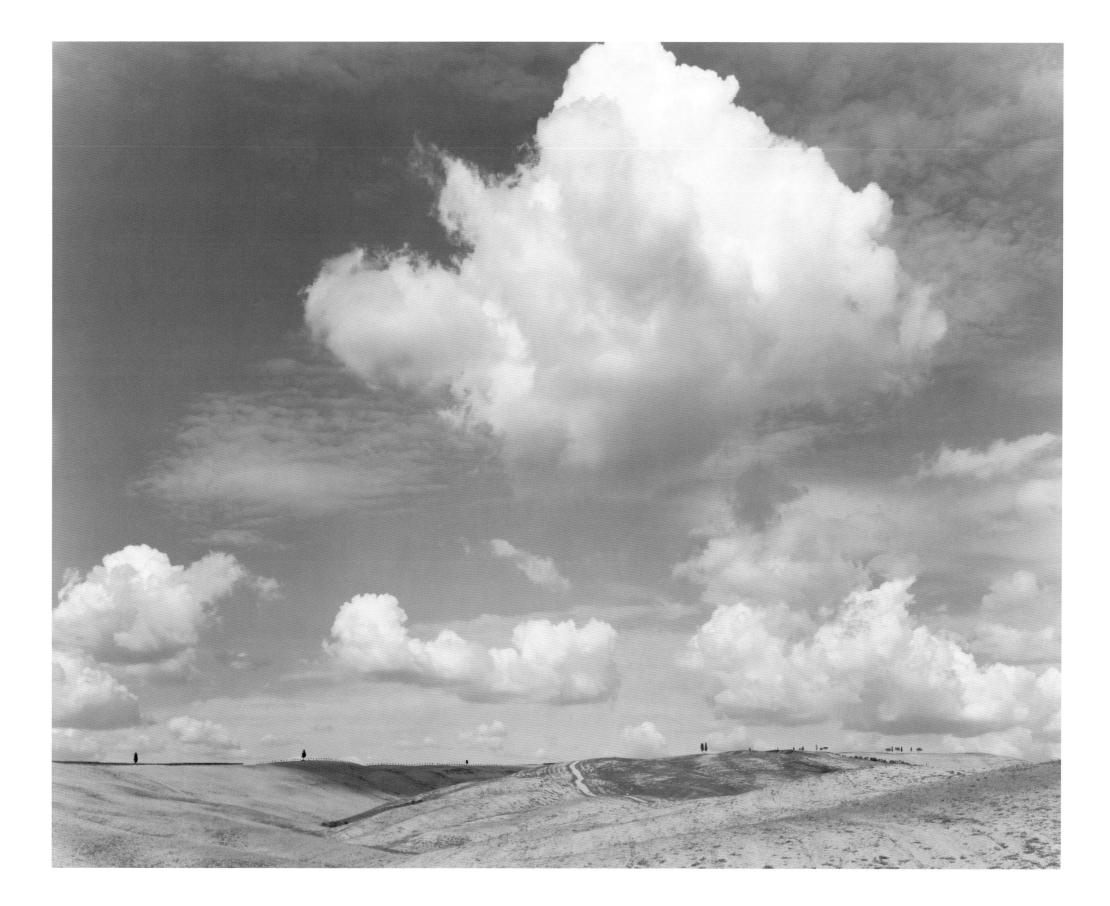

oel has been making a photograph of the

complexity and harmony of buildings, light, shadow, and our favorite linden tree. I sit beside him on a small flight of steps, dreaming, gazing, and thinking I should be writing. But I seem unable to put into words what I have been struggling to say all year. It is about the complexity of harmony that I have been trying to write: that particular musical quality that marries notes in such a way as to describe humanity's desire and sorrow. And now I see it before me, there in the drainpipe that pours itself down in a stream of color exactly matching that of the brick walkway it barely touches, the bricks fitting into each other like the spine of a sardine. And this dusty, faded color, the color of very old blood, runs down to a compressed pile of grape skins, the juice of which now sits in a vat awaiting its time of ferment. The pile of skins, which is both waste and the shape of things to come, resonates with the brick and the drainpipe and a lone patch of stucco on the wall behind it. This interweaving of necessity creates a harmony that is both simple and intricate. It is a small passage in the symphony of centuries of toil, composed by the generations who have truly lived here.

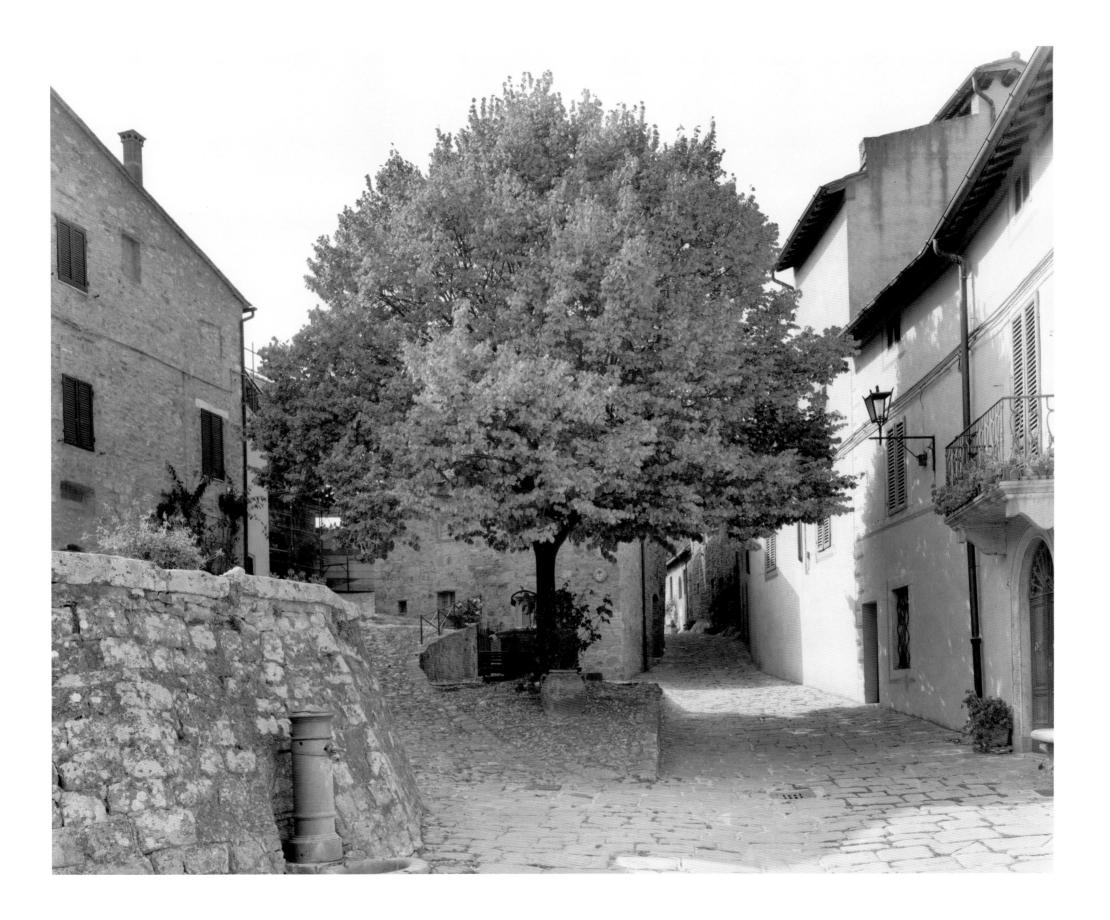

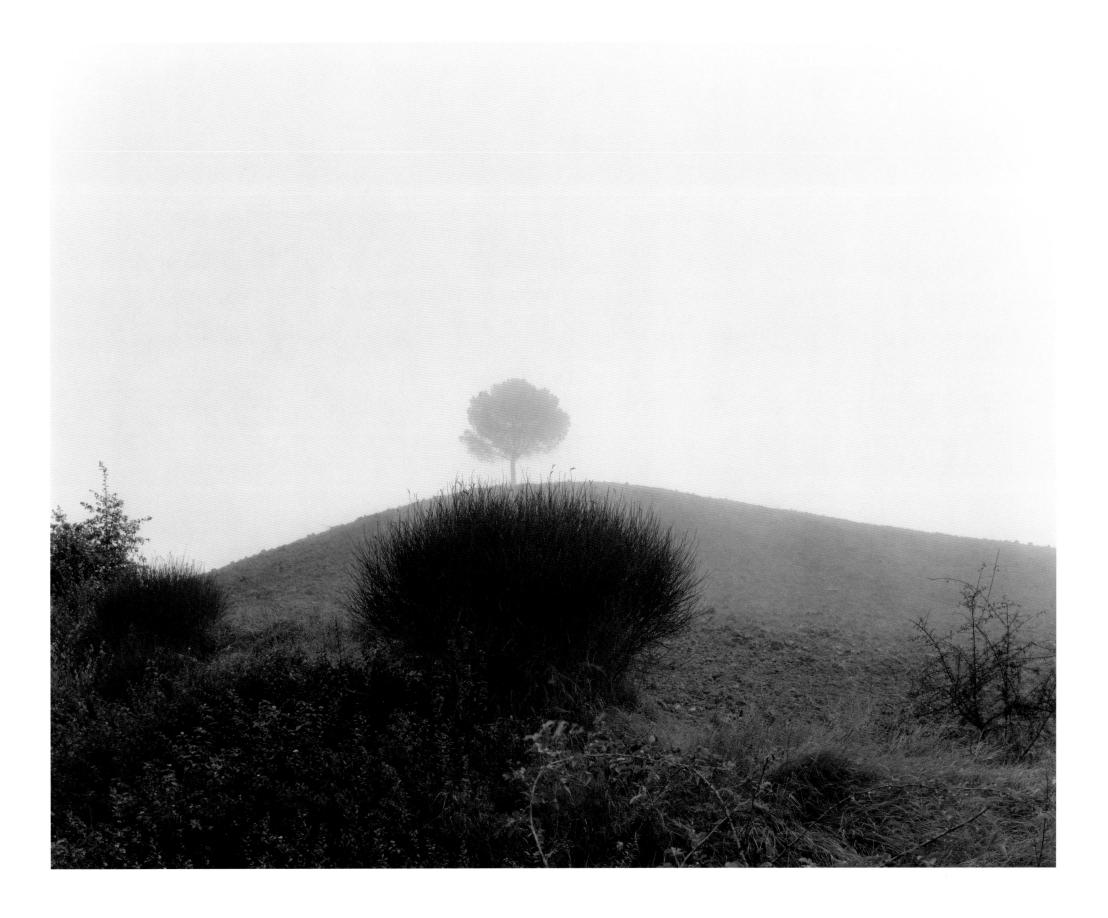

The sagra is over. Nine days of ritual in homage to the bounty of the land, and everywhere you look there is food. During this time the town experiences a spirit of community that is its true bounty, and we are left with everlasting images. The surprise of rounding a corner to see a street filled with tables. A seventy-year-old woman standing over an enormous pot of polenta, stirring it with a spoon the size of a spade; just standing, staring, stirring, in the corner of a furious kitchen. A boy's unlined face beaming with the joy of life, the way it will fifty years hence. Teenagers—pierced and tattooed like the rest of the world's youth—carrying trays of food with a good will that belies the belligerence of their fashion. An eighty-year-old woman, tiny at the sink, working her way through stacks of dirty plates with all the concentration of a Zen monk. Floriana, standing up at her table in the packed courtyard singing like a six-year-old. Lisena, her white cap atilt, feeding us straight from the fire.

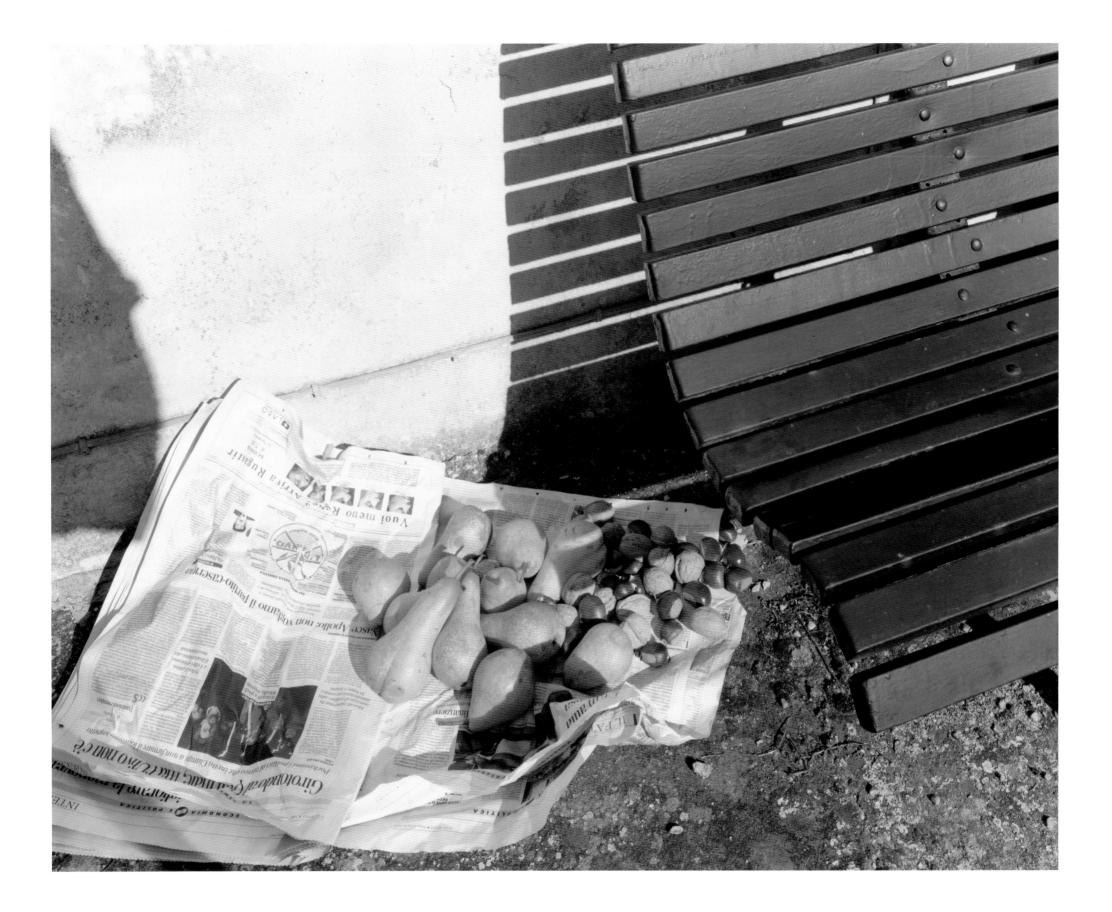

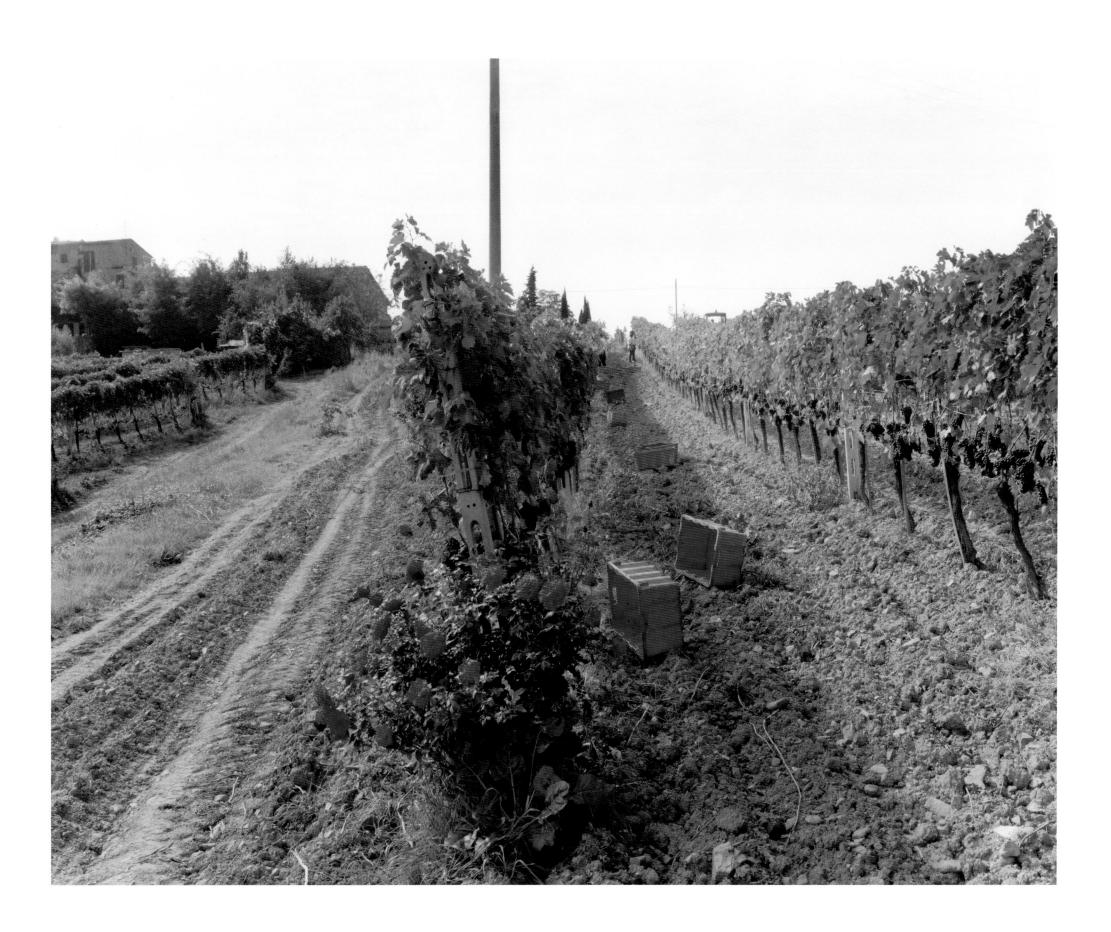

A Harvest Lunch

Pane

Pasta con lepre

Potate con formaggio e prosciutto

Focaccia

Pansante

Ricciarelli

Torta

Vino

Aqua

Vinsanto

Grappa

Espresso

I vineyard owner

3 fulltime workers

5 local firemen

2 guys from Elba

4 students

3 cooks

I photographer

I writer

2 hours

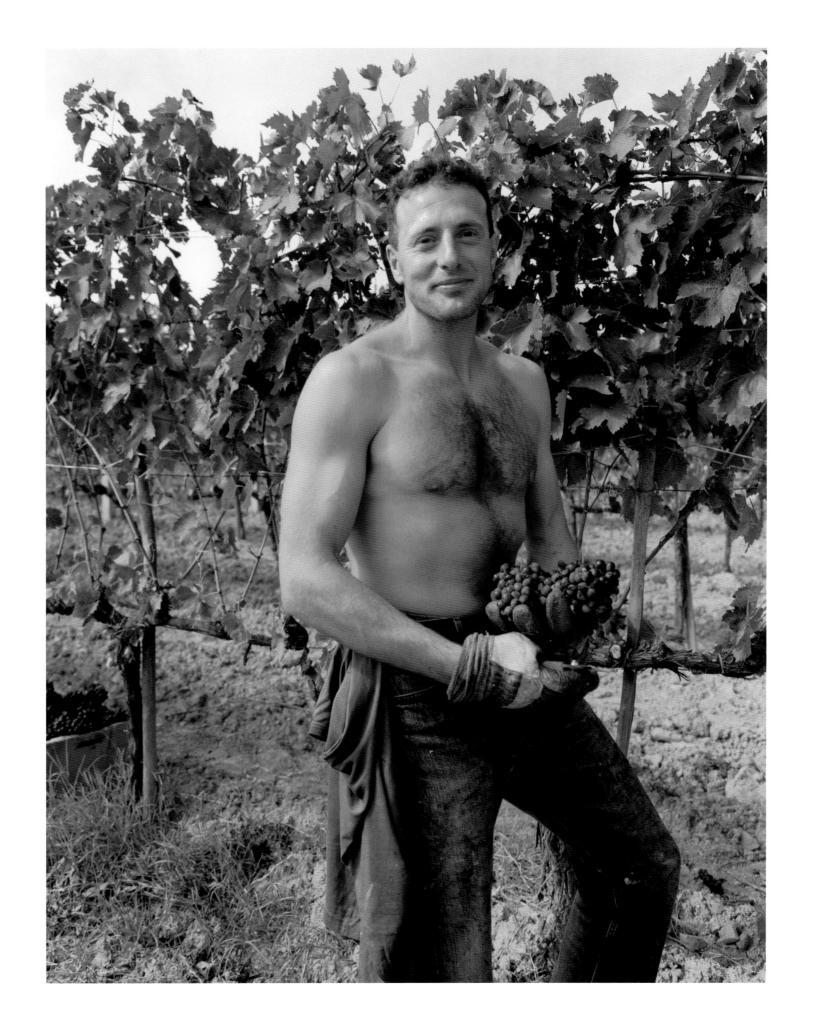

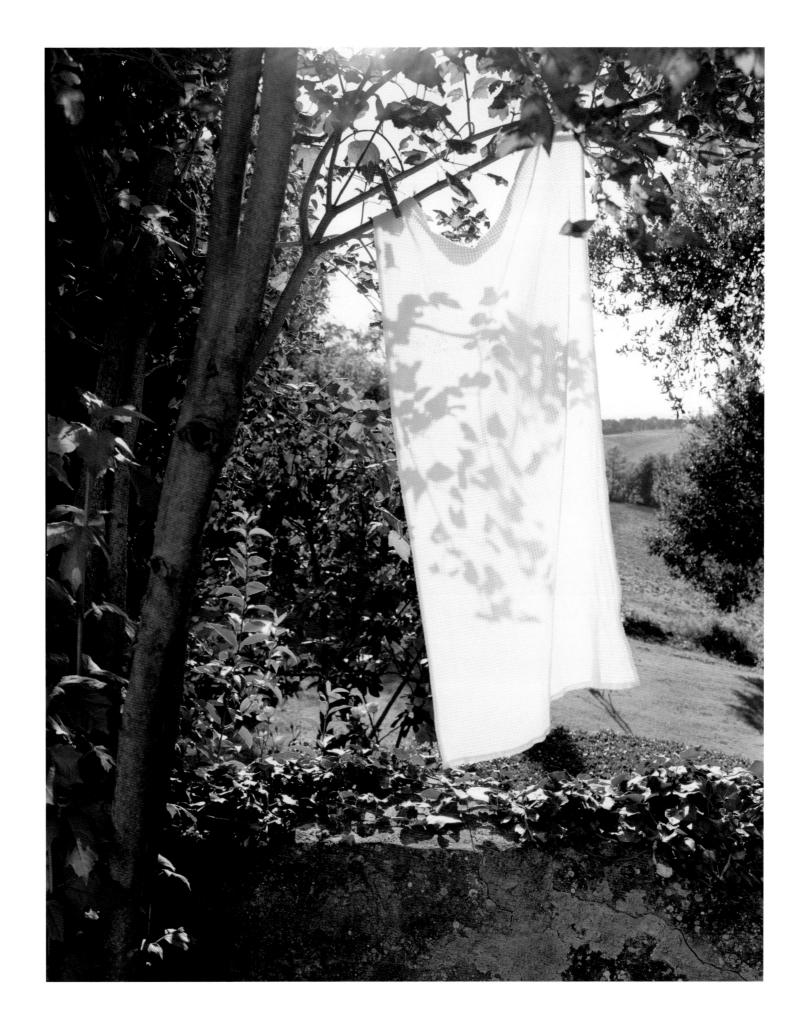

The evening is still. It is every evening that ever

was. Then, a sudden shiver stirs the poplars and the air is filled with dust, lit orange by the setting sun. A stair to nowhere anymore prompts a flight of the imagination. Who trod those worn steps, trailing a hand on the warmth of the iron railing? Where did they go when they turned right at the top and disappeared into an opening in the maroon ivy? A sound comes across the courtyard: a boy sings his solitary syllable for us and in this sound all language is condensed. This vowel-laden sound is his yes, his no, his come and go. His *babbo* calls to him, over and over, each syllable of the name as measured as the child's one note.

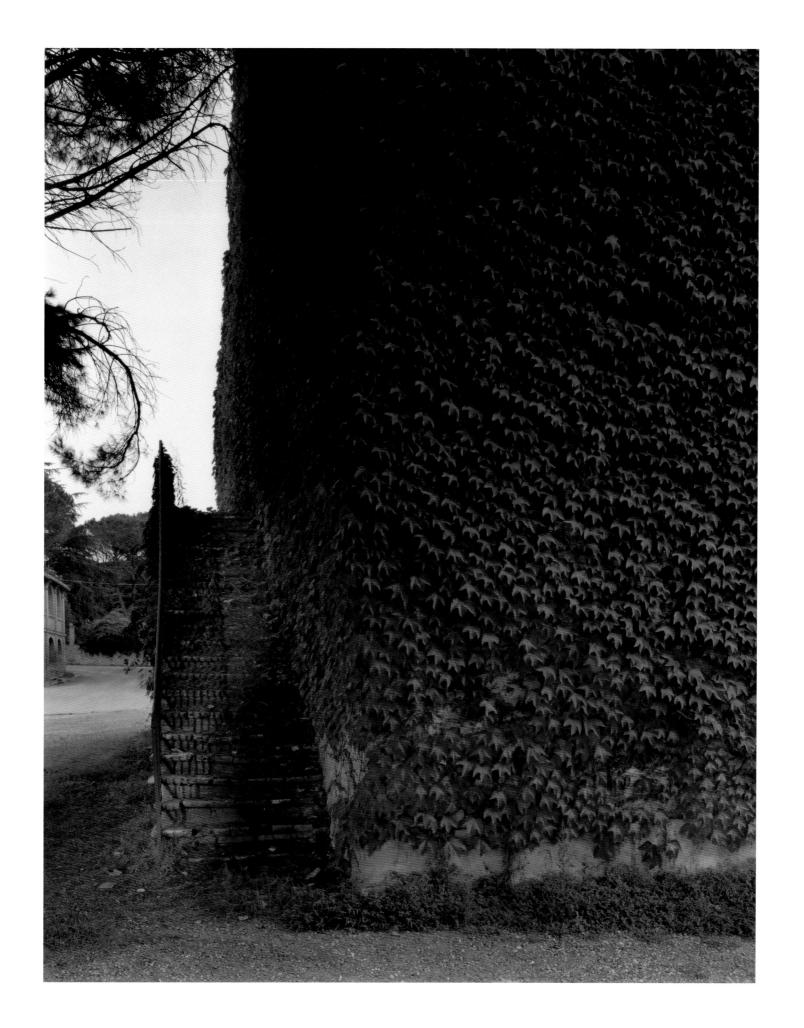

PLATE 67

Overleaf: Plates 68 and 69

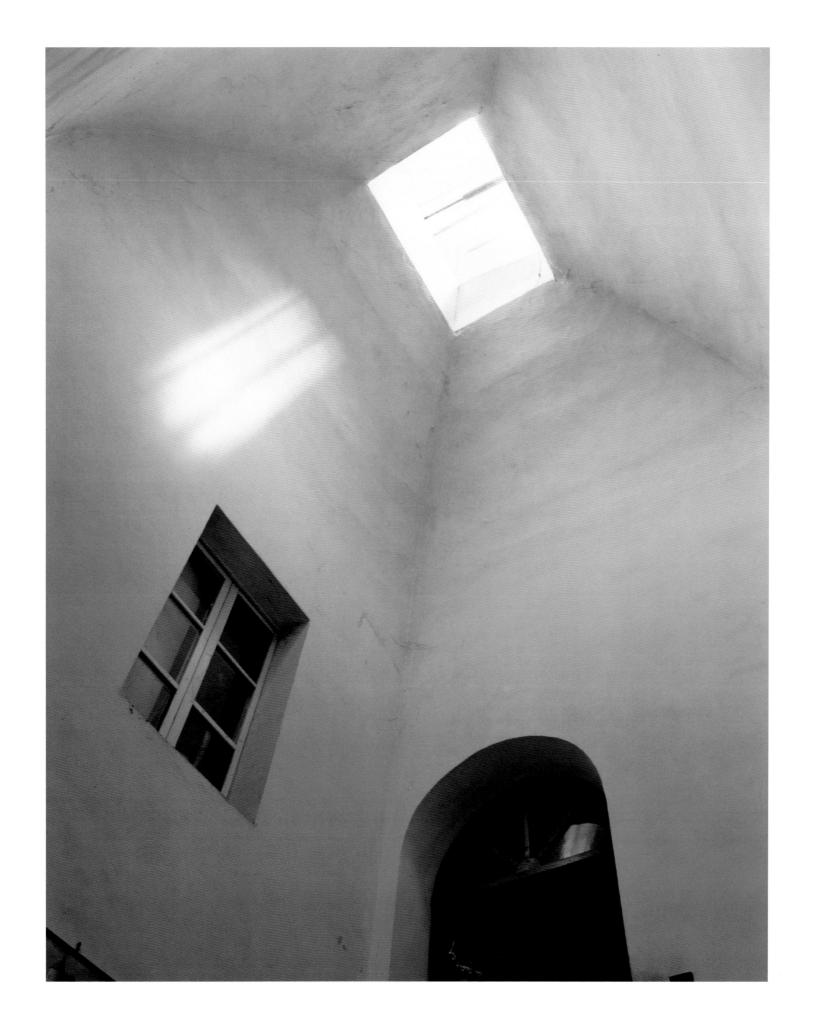

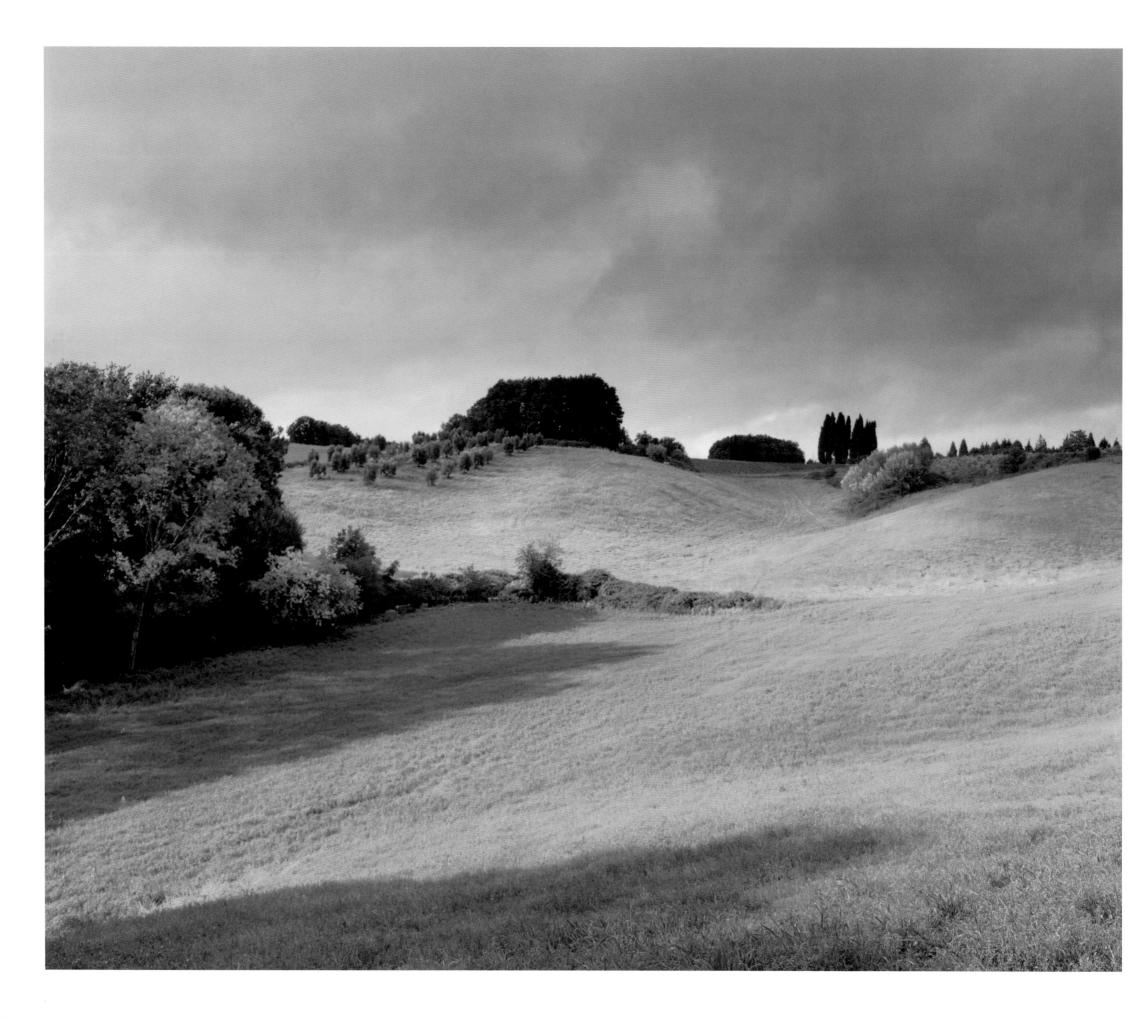

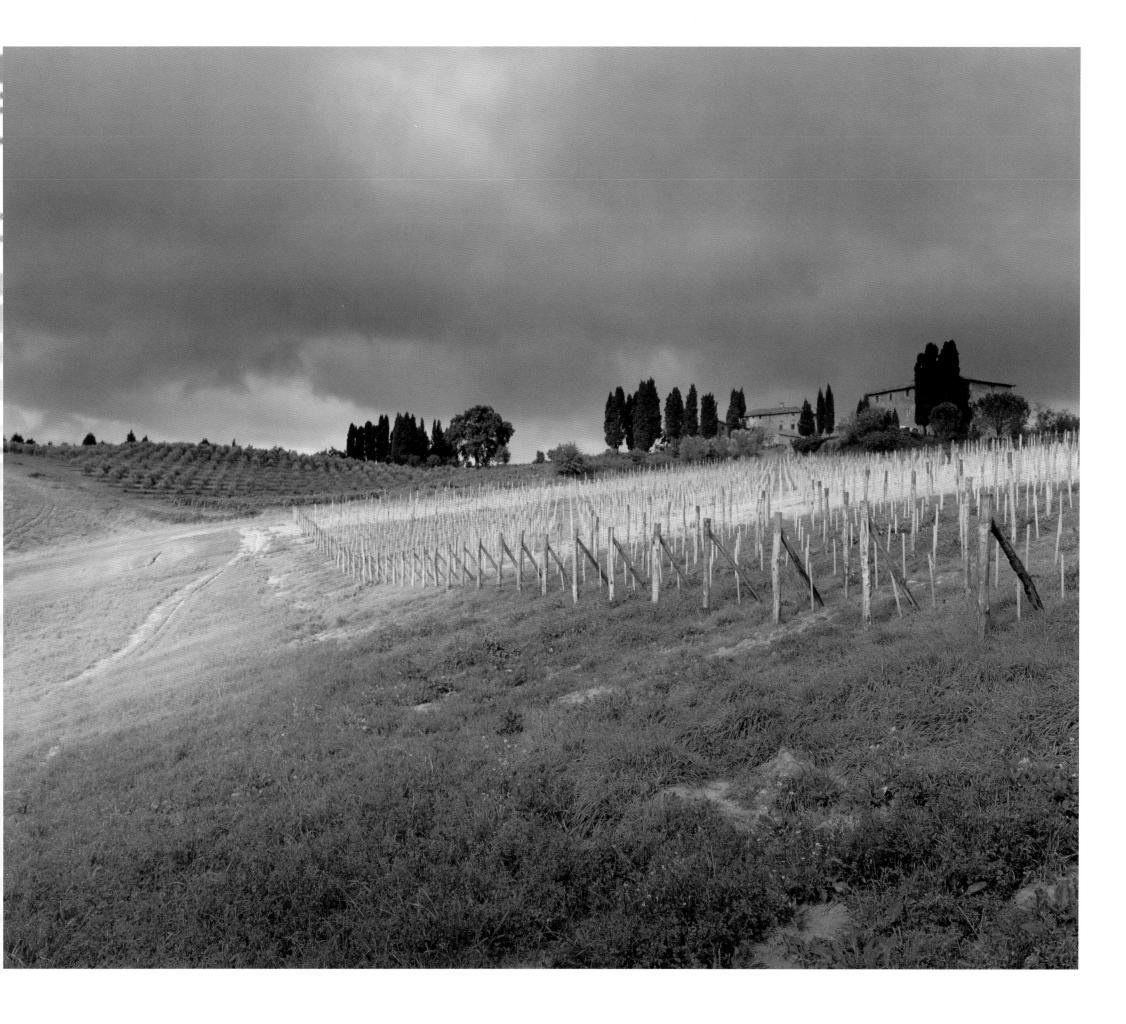

love olive groves. There is one on the right, just before we turn off for home. I've seen it for years, but for the last two weeks it's been speaking to me like never before and I'm not sure why. I know that what pleases me visually is that the field in which the grove stands has been mown recently, leaving stripes of longer grass uniting each tree. Is that what satisfies me, this linking of the individual to the whole? Strange that in this tying together, the solitary becomes more noticeable. As the light disappears, these lines of long grass take on the same value as the trees, so that the mown field is now a faint green sea upon which each tree sails its own cresting wave. Is this the mystery that has spoken to me? The mystery of the long-gone sea, once again made present? And is this what I love so much about this land—that everywhere, all the time, there is physical and visual evidence of the accumulation of history? And is this not reassuring? For if a grove of olive trees standing in a mown field can give one thousands of years of history, then perhaps each of us, too, makes a mark by our very existence.

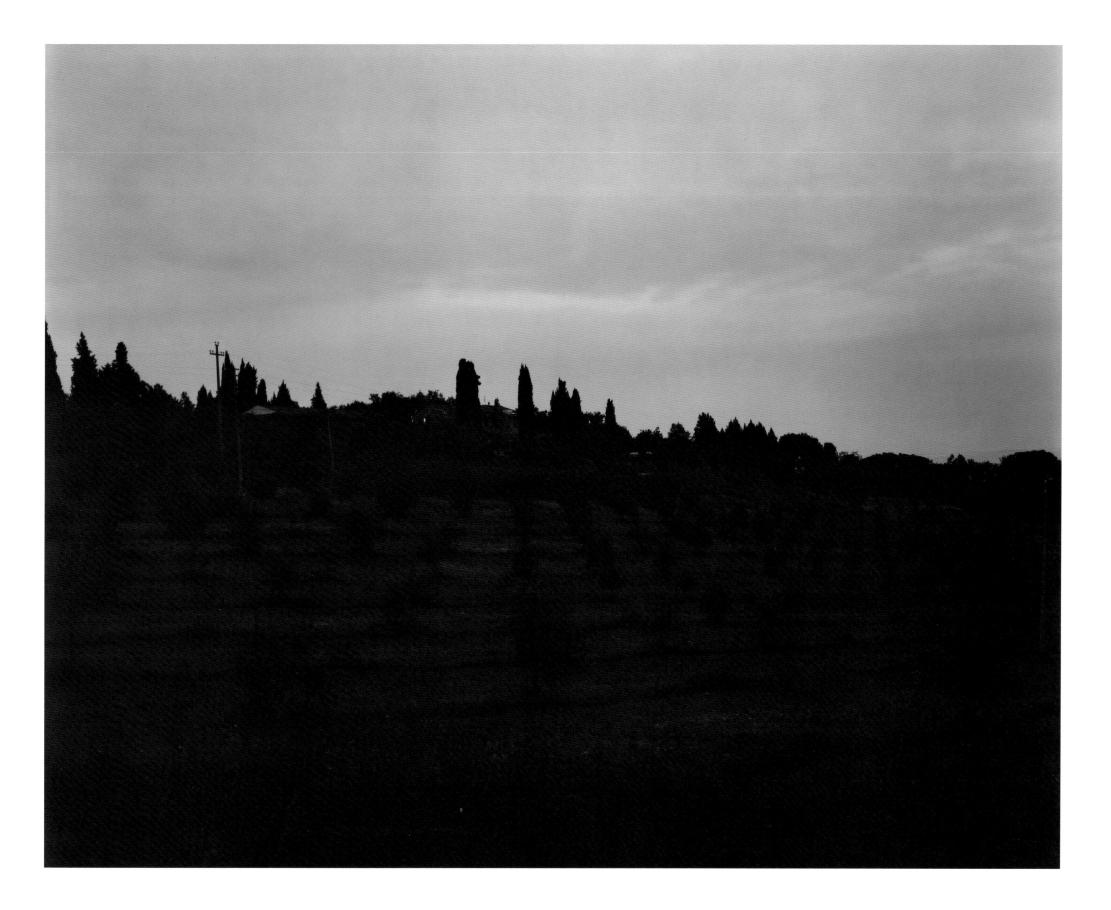

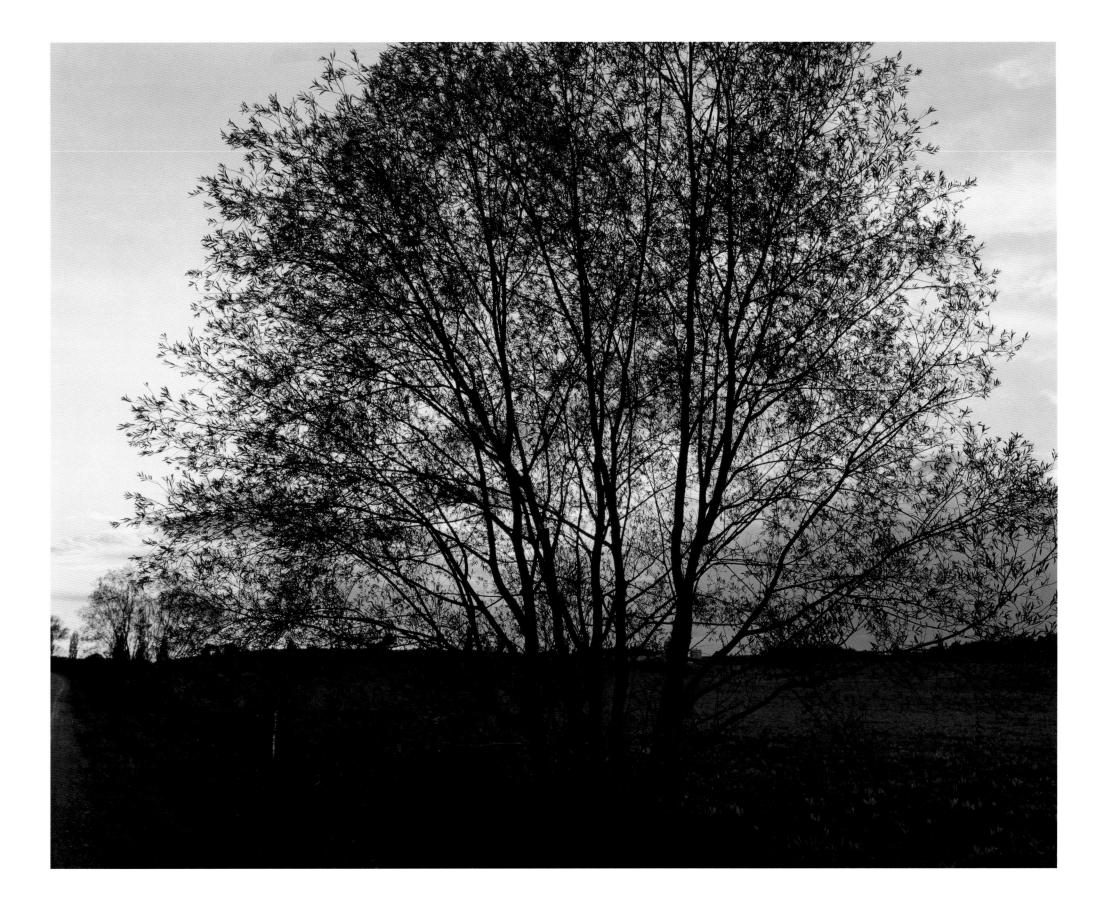

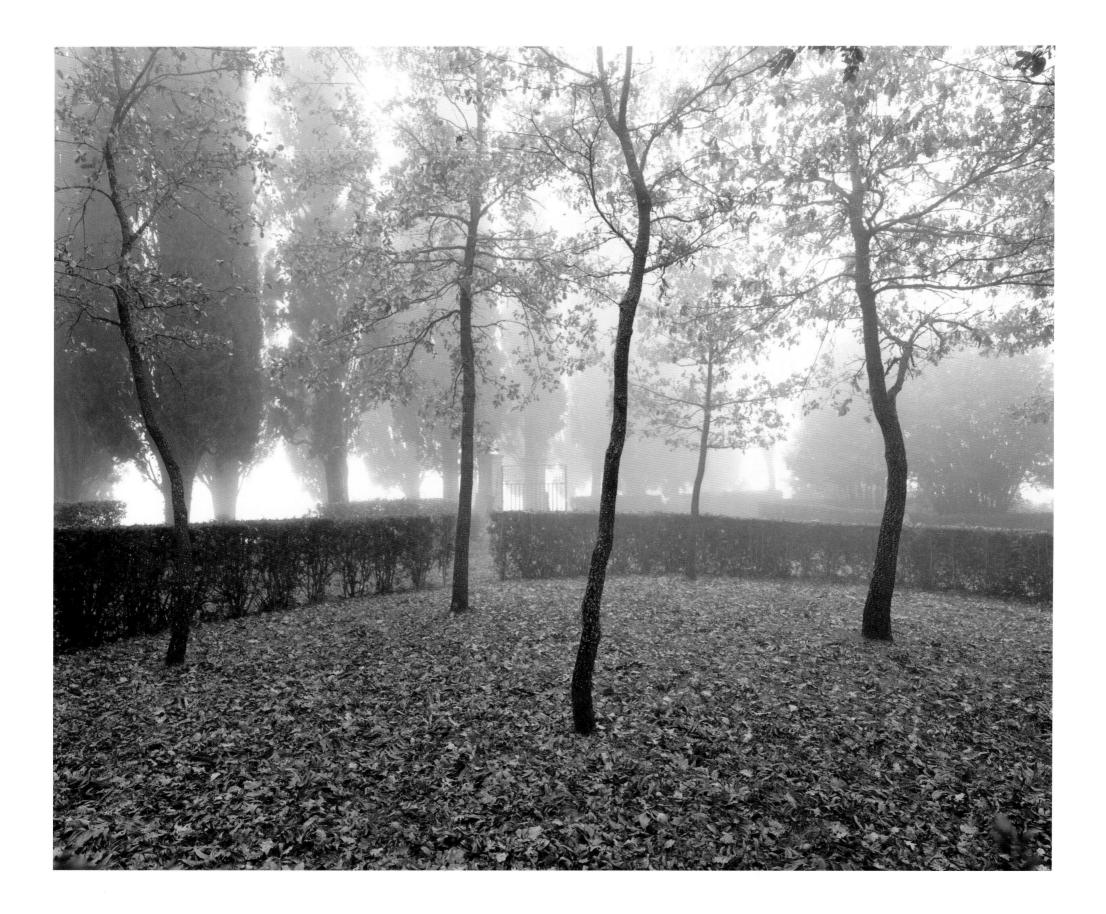

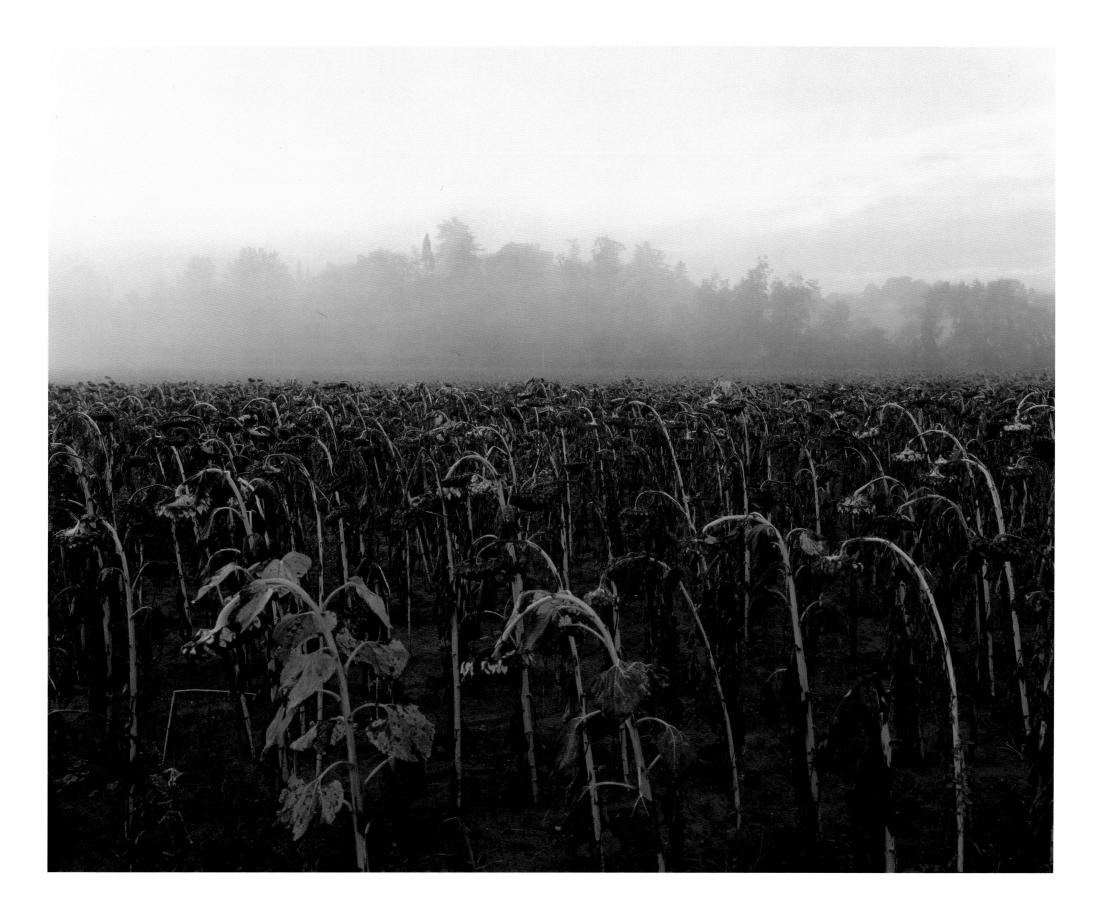

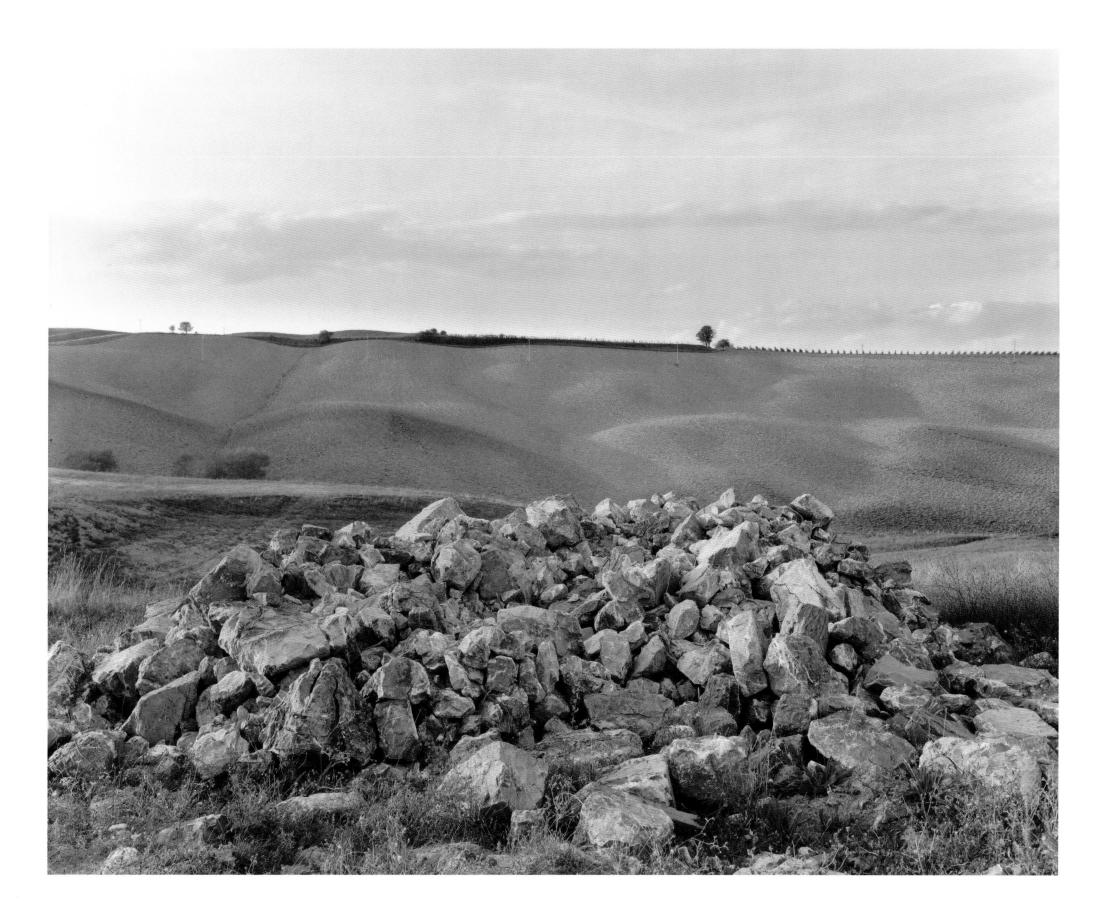

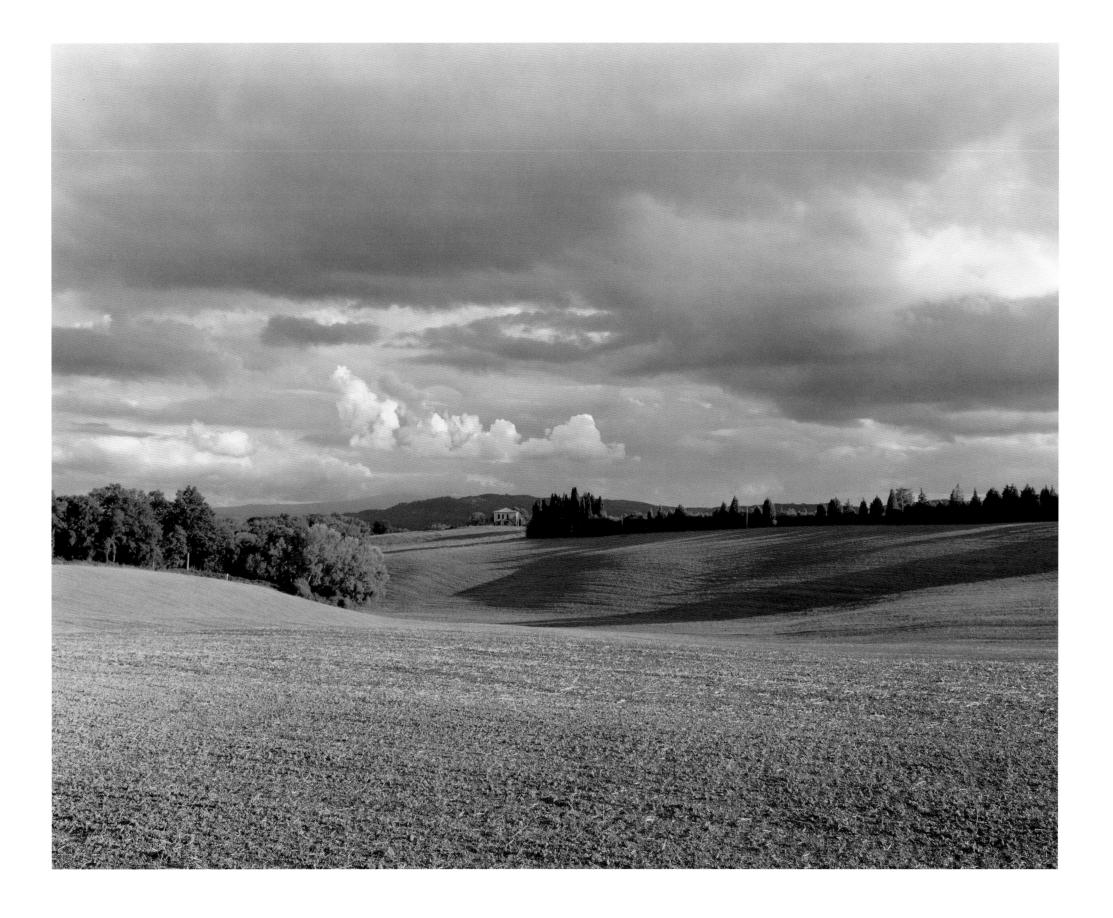

We make portraits of our friends, a harvest

of love. Today it is Mario and Elvio. These men are of the earth. Take the time to discuss with them the light, the shape of a hill in the morning, or the way that field is a different color in the spring, ask them the name of any plant or tree, remark on the beauty of the day or the serenity of the evening, and they will turn to you with smiles and tell you everything you have experienced... and more. The truth is we only visit this land, they live it. We are fortunate, they are blessed. So we stand now, in the last season, by a vast field of tilled earth and expect, any moment, to see it move forward and undulate at our feet. This sea of pale, dry sod holds in its emptiness the possibility of all that is to come. And what will be next? Wheat, potatoes, sunflowers, corn? Like the spokes of a wheel, these rotating crops keep the engine of cultivation rolling. Long may it come and go. Long may our friends live here and pass on their knowledge and wisdom, their tradition and spirit, and long may we be allowed to bow before it, to look and breathe it in and germinate it. For good land and its traditions are more important to the world than ever before.

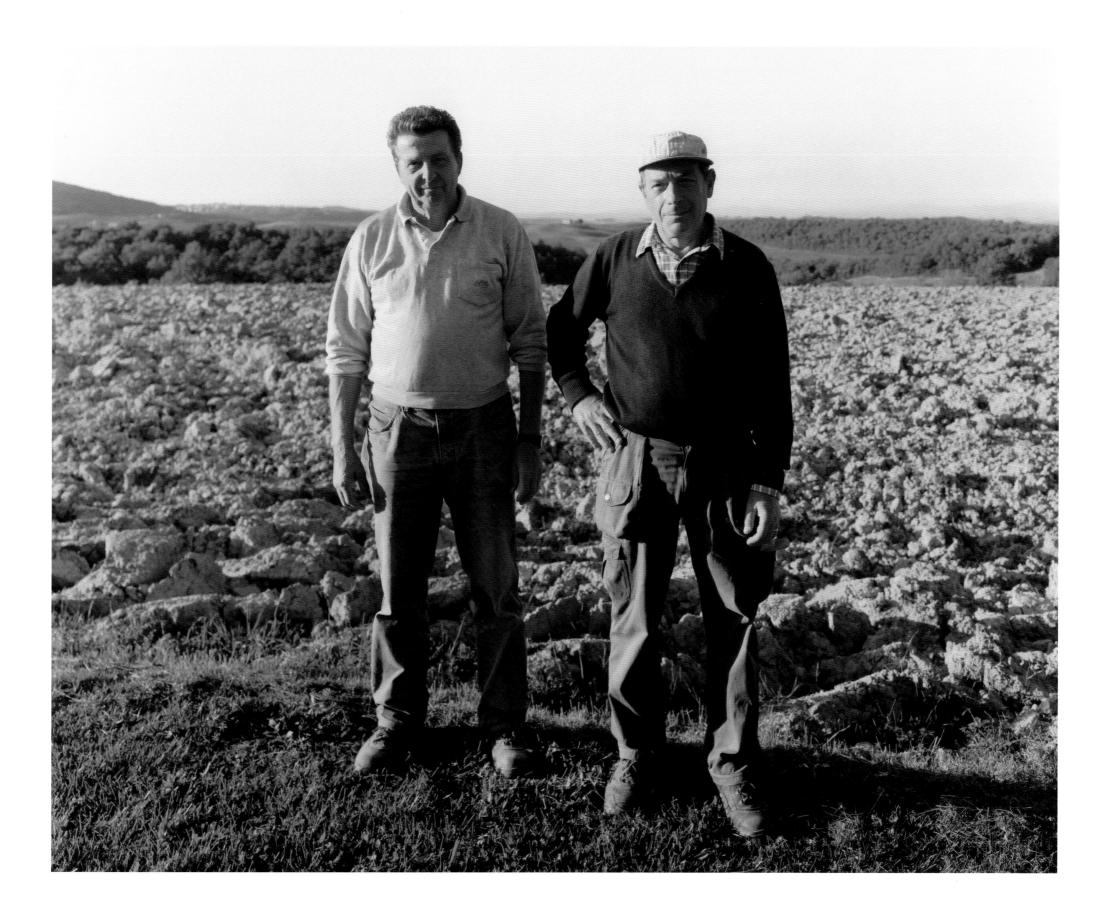

Am I explaining what the camera sees? I tell him the photographs need no explanation. This is a book of marriage: between two people, two mediums, two visions. So when we sit in Gianni's house and look, really look, we see that the house represents a way of life that most of us have turned from.

A way of life that is about having only what you need, when you need it. And those needs are directly linked to the land. It's all about food—the one thing we all still need. Here are the tools: scythes, saws, tongs, clippers, axes, hammers, knives, presses, scales, and sieves, handmade, to tend the land, to grow the food, to harvest the crops, to press the grapes, to butcher the meat. Here are the tools to thresh the hemp, to make the string, to weave the baskets. Here is the hearth to bake the bread and warm the soup. This house is the essence of Gianni, and for us, Gianni is the essence of Toscana. For in the end, while the land may feed our eyes and our bellies, it is our relationships that feed our hearts.

We came here because of the light, because the light is an intrinsic part of the life here and because people like Gianni and his family keep the light burning for us all.

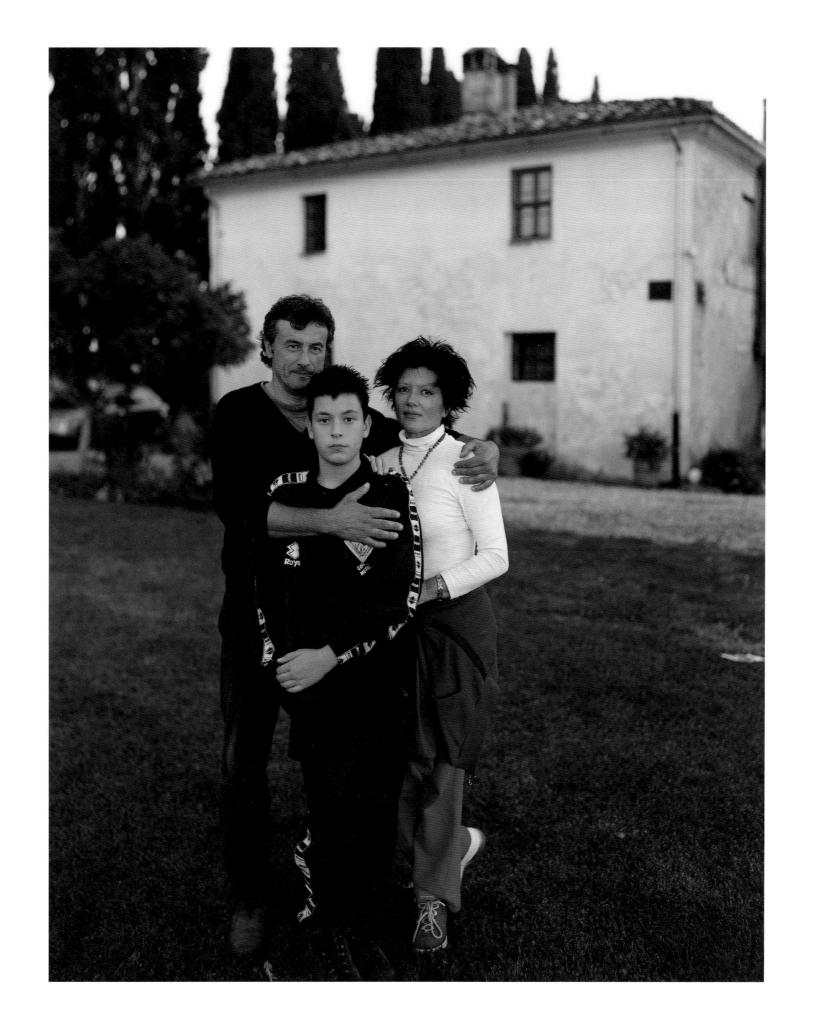

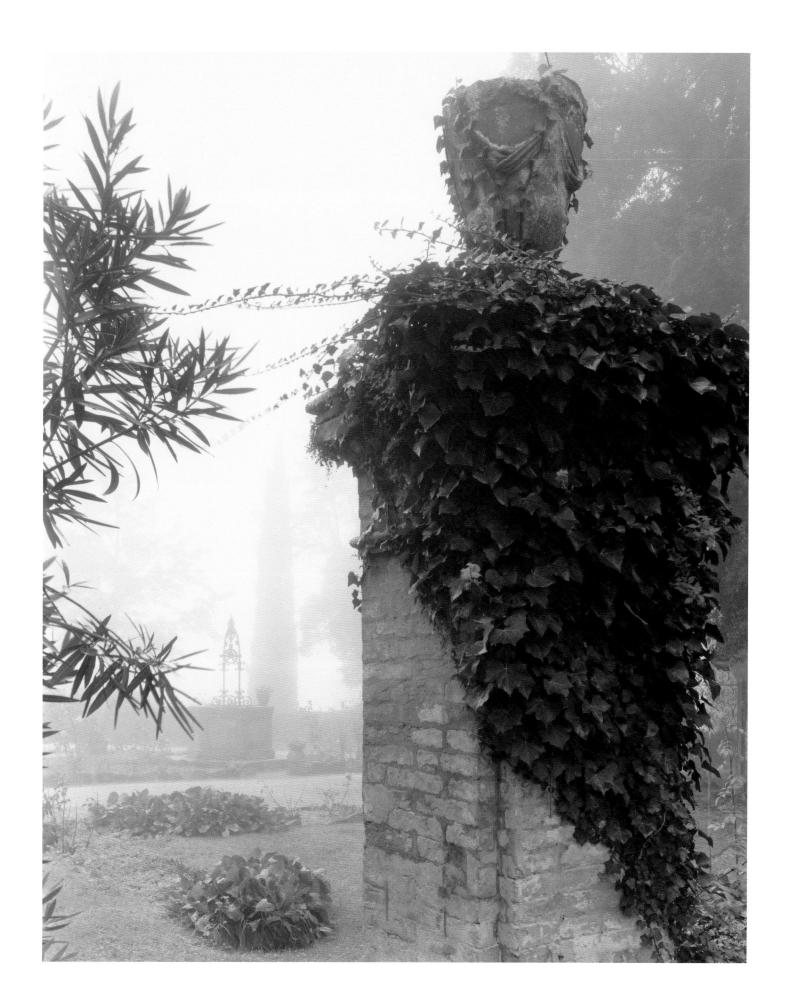

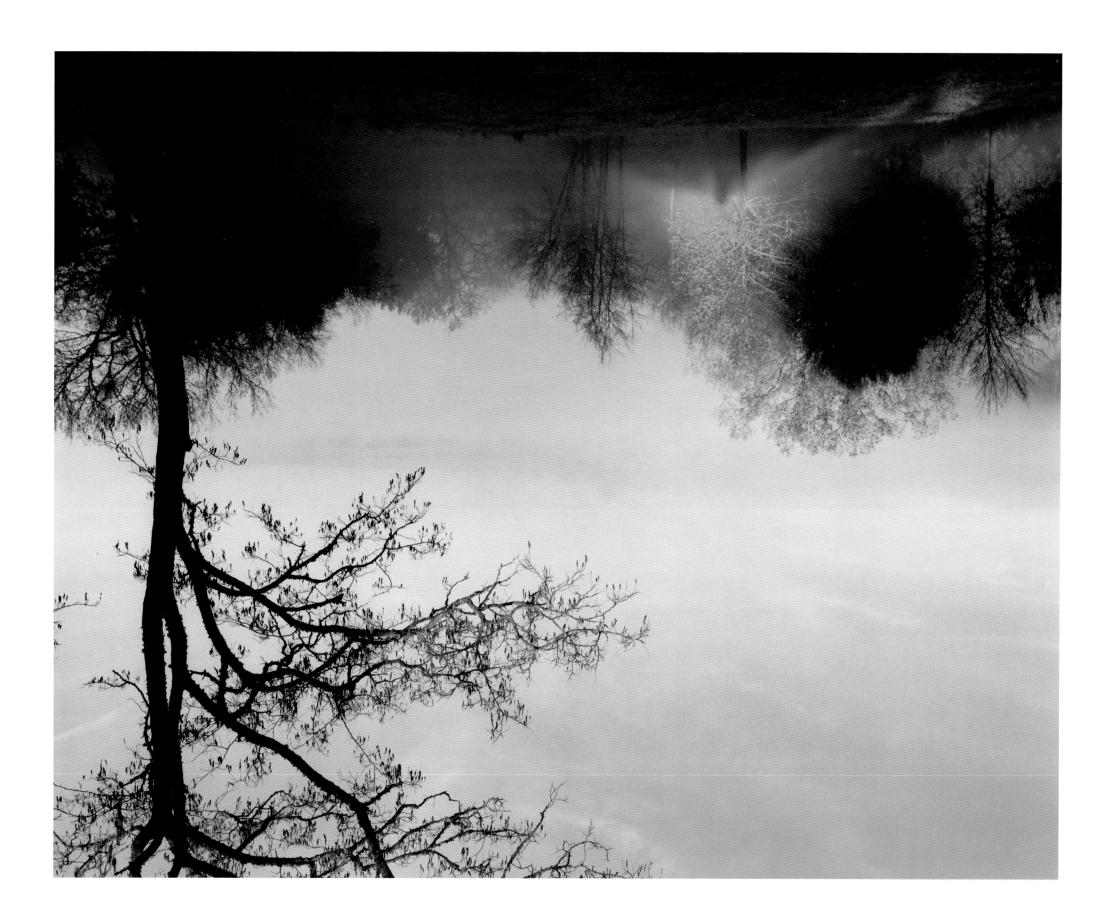

rigital OF Frank S

Overture 1: Winter—Late Afternoon Overture 2: Spring—Vineyard, Passing Storm Overture 3: Summer—Early Morning Mist, Rising Overture 4: Autumn—Last Light

WINTER

Grass in Olive Grove	St Stel9	in9tsi₩	15 etal9
Road in Springtime	It steld	Тhe Land, Dusk	OS etal9
(thgiA)	Ot albI9	nəzori zaH tziM ərlT	Plate 19
Storm in the Valley (Left)	Plate 39	nətniW ni səərT gnuoY	81 stel9
Field of Poppies	8E ətal9	The Dinner Table	VI ətsI9
(tdgiA)	√£ ətal9	Winter Ritual	81 Stel9
(rehte⊃)	Dlate 36	The Woodcutter's Art	ZI ətal9
(fled) gning (left)	28 etsI9	evond evilo	Plate 14
gninq2 ni s∍∍nT gnuoY	Plate 34	llsW √vall	Flate 13
moola taniA	FE estel9	Two Columns	SI ətsI9
lsmrət∃ zl gninq2	SE etal9	Tvees	II ətsI9
Tree and Stick	IE ətal9	Castle Woods in Rist	Ol ətsI9
Cypresses, Moonrise	OE etal9	The River, Late Afternoon	9 Stal9
The Fireplace	Plate 29	Frost on Turned Field	8 ətsI9
Crypt, Relic	Plate 28	Alpled Field	7 ətsI9
Isnoissatro	Nate 27	Hill Mew Grass	9 stal9
9ldsT mooA gniniQ	Plate 26	Red Field, Dusk	2 ətsI9
The Day the Air Turned Green	25 ets19	Rolling Hills and Cloud	Plate 4
The Chapel	Plate 24	Landscape, Midmorning	E atsI9
The Gate	EL atel9	Cypresses, Early Morning	S ətalq
moold ni sinətsiW	SZ əjalq	Jam Trees in Mist	l ətal9

SUMMER

JdgiJ JzniA	e7 sts19		
Courtyard, Early Morning	87 əts19		
Gianni, Luanna, Giovanni	TT atsI9		
oivI∃ bns oinsM	Plate 76		
Fields and House	27 Stel9		
Fields and Stones, Late Afternoon	Plate 74		
tsevnaH aht not gnitisW	Flate 73		
Cincle of Trees	Plate 72	Summer Evening, After Storm	72 Stal9
Clouds and Tree, Dusk	I \ \ \ \ \ \ \ \ \ \ \ \ \ \ \ \ \ \ \	Sea and Sky	92 stal9
Shtfall	OV stal9	Road to the Sea	SS stal9
(JAgiA)	98 etal9	Maggie and Cypress Tree	Plate 54
Vineyard, Late Afternoon (Left)	88 stel9	sehonA	EZ atsI9
Interior, Stairwell	78 Stel9	The Well, Late Afternoon	S etal9
tdgiJ tebJ	99 stel9	Interior	12 sts19
nu2 ədt ni gniyrol ləwoT	28 Stel9	Chapel in Morning Mist	OZ stal9
saganD Atiw naM	Plate 64	bsoA 9JihW	94 Stal9
Harvesting the Grapes	Flate 63	Life on the Street	84 stal9
The Gift	Plate 62	MiO gnuoy	74 Stal9
tsiM ni əni9 bns IliH	18 Stel9	sbl9itysH	46 9tel9
Jhe Linden Tree	08 stal9	Road in Summer	24 Stel9
A September Day	92 stal9	SperT evilO	At Stel9
Peppo	82 stsI9	Wheat Field, Late Afternoon	Elate 43
		NUI O LOV	

Published by Sterling Publishing Co., Inc. 387 Park Avenue South, New York, NY 10016

Photography ©2003 Joel Meyerowitz Text ©2003 Maggie Barrett

Distributed in Canada by Sterling Publishing

clo Canadian Manda Group, One Atlantic Avenue, Suite 105

Toronto, Ontario, Canada M6K 3E7

Distributed in Great Britain by Chrysalis Books

64 Brewery Road, London N79NT, England

Distributed in Australia by Capricorn Link (Australia) Pty. Ltd.

P.O. Box 704, Windsor, NSW 2756, Australia

All rights reserved. No part of this publication may be reproduced, stored in a retrieval system, or transmitted, in any form or by any means, electronic, mechanical, photocopying, recording, or otherwise, without prior written permission from the publisher.

ISBN 1-4057-1109-3

Editor: Susan Lauzau

Art Director/Designer: Jeff Batzli
Photography Director: Christopher Bain
Production Manager: Michael Vagnetti
Production Director: Karen Matsu Greenberg

Printed in Singapore by CS Graphics Printed in Shts reserved

7 + 9 8 01 6 4 5 8 1

ACKNOWLEDGMENTS

Like all successful marriages, this one—between image and text—

owes much to the many people who believed in it and lent their support.

First among these is Gianni Mariotti, without whose help, friendship, and deep knowledge of all things Tuscan our work would have been more work than the pure joy it was. And thanks go to the Venturini family on whose estate we made our home over the four seasons it took to complete our book. The work of processing and printing done by Scott Hagendorf of LTI Labs in New York and Bob Korn Imaging on Cape Cod required exquisite control and was consistently of the highest quality. We particularly want to thank Jorge Ochoa and Philip Heying for making the master prints with Joel and never ceasing to work toward the most subtle and luminous rendering of the images. So, too, photographs are only as good as the film they're made on, and for that we have to thank Kodak for generously supporting this project. Our heartfelt thanks and gratitude to Joel's studio staff, without whose hard work and loyalty this book could never have been made. They are: Ember Rilleau, Susan Jenkins, John Saponara, Jon Smith, Liz Jonckheer, Ali Silverstein, Lauren Knighton, Lisa Mauceri, Melissa Piechucki, and Carre Bevilacqua. Getting around in Tuscany was made easier by the generous support of Auto Europe car rental of Maine. To all our Tuscan friends who took us into their homes and hearts we are forever grateful. Their spirit is with us every day and renews our faith in the inherent goodness of humanity.

We must, of course, thank the many people at Barnes & Noble whose belief and support in our project brought it to the elegant finish we see here. Every one of them showed an integrity that made this publishing experience a thrill. They are: Jeff Batzli, for his exquisite design; Michael Fragnito, for his guidance; Susan Lauzau, whose light touch and insight as an editor are deeply appreciated; Karen Greenberg and Michael Vagnetti, for shepherding the book so caringly through production; and Lee Stern, for his enthusiastic support.

And most of all, our everlasting gratitude and thanks to Michael Friedman and Chris Bain who, by asking us to collaborate on this book, gave us the best wedding present imaginable.

	•			